DISCOVER DRAWING SERIES

Draw Real Animals!

Lee Hammond

NORTH LIGHT BOOKS
Cincinnati, Ohio

ABOUT THE AUTHOR

Polly "Lee" Hammond is an illustrator and art instructor now living in Portland, Oregon. She specializes in portrait drawing, but practices, teaches and enjoys all subjects and art mediums.

She was raised and educated in Lincoln, Nebraska. She built her career in illustration and art instruction in the Kansas City area, and has lived all over the United States.

She is now concentrating on a career in seminar instruction in a variety of art techniques, art product demonstrations, and writing more art instructional books. She is also expanding her writing into short stories and children's books, which she also illustrates.

"Lee" is married to Chris Hammond, and is the mother of three children, Shelly, LeAnne and Christopher. She also has a granddaughter, Taylor Marie.

Draw Real Animals! Copyright © 1996 by Lee Hammond. Printed and bound in the United States of America. All rights reserved. No part of this book may be reproduced in any form or by any electronic or mechanical means including information storage and retrieval systems without permission in writing from the publisher, except by a reviewer, who may quote brief passages in a review. Published by North Light Books, an imprint of F&W Publications, Inc., 1507 Dana Avenue, Cincinnati, Ohio 45207. (800) 289-0963. First edition.

Other fine North Light Books are available from your local bookstore, art supply store or direct from the publisher.

00 99 98 97 96 5 4 3 2 1

Library of Congress Cataloging-in-Publication Data

Hammond, Lee. 1957–
 Draw real animals! / by Lee Hammond.
 p. cm.
 Includes index.
 ISBN 0-89134-658-9 (pbk. : alk. paper)
 1. Animals in art. 2. Drawing—Technique. I. Title.
NC780.H24 1996
743'.6—dc20 95-40851
 CIP

Edited by Julie Wesling Whaley
Interior and cover designed by Brian Roeth

North Light Books are available for sales promotions, premiums and fund-raising use. Special editions or book excerpts can also be created to specification. For details, contact the Special Sales Manager, F&W Publications, 1507 Dana Avenue, Cincinnati, Ohio 45207.

METRIC CONVERSION CHART		
TO CONVERT	TO	MULTIPLY BY
Inches	Centimeters	2.54
Centimeters	Inches	0.4
Feet	Centimeters	30.5
Centimeters	Feet	0.03
Yards	Meters	0.9
Meters	Yards	1.1
Sq. Inches	Sq. Centimeters	6.45
Sq. Centimeters	Sq. Inches	0.16
Sq. Feet	Sq. Meters	0.09
Sq. Meters	Sq. Feet	10.8
Sq. Yards	Sq. Meters	0.8
Sq. Meters	Sq. Yards	1.2
Pounds	Kilograms	0.45
Kilograms	Pounds	2.2
Ounces	Grams	28.4
Grams	Ounces	0.04

DEDICATION

This book is dedicated to my cat J.J., whom we recently lost, and all of the wonderful animals we have had the pleasure of sharing our lives with. Duke, Danny, Brandy, Zephyr, Puds, Poppy and Peaches and Tippy, are just a few who enhanced our world. Also, this is for my wonderful children, Shelly, Le-Anne and Christopher, and my granddaughter, Taylor, who share my love of animals. Thanks to you all, for making my life so much fun!

ACKNOWLEDGMENTS

Nothing we do in this life is ours alone. Although the writing that I do comes from my heart, it would not be possible without the help and encouragement of others. Thank you, Julie Whaley for all the wonderful suggestions and help in putting this book together. I'm sure it was no easy task. Thanks to all at North Light Books, who continually give me the chance to share my love of art with others. And a huge thank-you to all of my students, who always teach me how to do it better through their eagerness to learn. And most of all, thanks to my husband, who is always there with support and willingness to take over the family in my absence. I love you all!

CONTENTS

CHAPTER ONE

You Can Do It!.................... 7

Learn what makes a good animal drawing—the author's secret to drawing realistically! See student work before using these techniques and after. Their progress will inspire you—you can have the same results!

CHAPTER TWO

Using the Right Materials.................... 10

You don't have to spend a fortune, but to draw like a pro you need the right tools. Find out what they are and how to use them.

CHAPTER THREE

Shapes.................... 12

In order to draw realistic-looking animals, learn to see them as shapes that fit together like a puzzle. Here are some warm-up shape exercises to get you started.

CHAPTER FOUR

Shading.................... 22

You can make shapes look dimensional with shading. Learn how to shade any shape using pencil, tortillion and kneaded eraser. Then you'll start to put shapes and shading together to begin drawing animals.

CHAPTER FIVE

Facial Features.................... 36

Now you can begin paying attention to details. Learn how to draw many different eyes and noses. It's still just shapes and shading, but you'll be amazed at how realistic they look.

CHAPTER SIX

Hair and Fur.................... 40

Many animals have hair, so you'll need to learn to draw all types from long, shaggy fur to short, curly hair and wispy, fine hair. The author shows how to render all kinds of hair realistically, from a squirrel's tail to a lion's mane.

CHAPTER SEVEN

Textures.................... 52

Most non-furry animals have wonderful textures to draw. Practice drawing a wrinkly elephant, scaly fish, shiny smooth dolphin and shark, bumpy lizard and alligator, and muscular horse.

CHAPTER EIGHT

Patterns.................... 62

See how to draw beautiful patterns on animals such as a frog, zebra, leopard, tiger, giraffe and bird. They look complex, but the author shows how to simplify the process of drawing them. Don't forget to add shading to make them dimensional!

CHAPTER NINE

Composition72

Learn how to make your drawings even more professional-looking by carefully planning their composition. Most subjects on a page appear in one of five basic "shapes" diagrammed here by the author.

CHAPTER TEN

Setting75

Learn secrets for extracting just the right elements from a photo to create a background for your drawing. You'll find out how to use contrast close up and make things appear blurry and far away.

Conclusion..79

Index..80

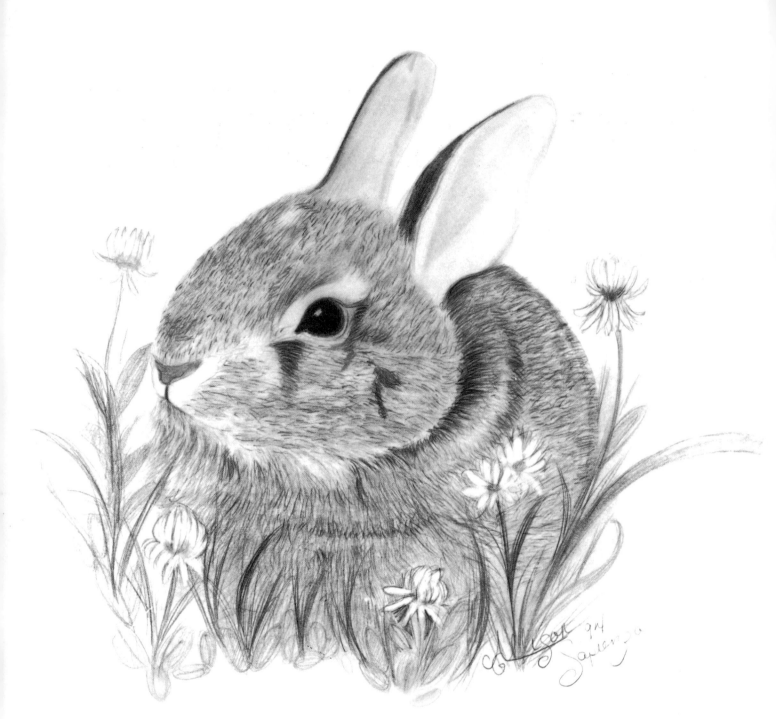

"Bunny"
by Allison Sapienza, age 11

This is a proud example of a young student's work. All it takes is the desire to learn, and the patience to apply the principles. Good job, Allison!

YOU CAN DO IT!

In all of my years of teaching art, I have found one universal trait amongst my students: the desire to draw ANIMALS! Our love of animals follows us from childhood on, along with our attempts to draw them.

As children, we were satisfied with our representation of animals on paper. A simple circle became the cat's face, an oval became a mouse and so on. But what happened when we got older? It became more difficult to capture the look we wanted. The question became, "How do I *make it look real?*"

This book is designed to take the frustration out of animal drawing. It will take you back to the simple approach we used as children, then lost as adults. It will show you a "procedure" that can then be used to draw *anything*!

The ability to make your drawings as polished as the ones in this book will take some time to develop, but don't worry! You will see improvement right away, and your drawings will become better and better. Practice is the real key here, and this is a fun book that will keep you wanting to draw.

This is a book for all ages to grow with. Just follow the step-by-step examples and you will be astonished at your results! If you don't believe me, just take a look at some of the student work, by very young students, that is presented here. You can do it too! You can make it look real!

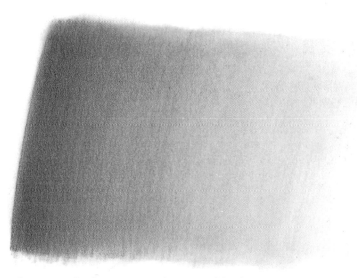

If you can do this, you can draw anything!

WHAT MAKES A GOOD ANIMAL DRAWING?

So what do you think makes a good animal drawing? It goes beyond just what the animal looks like. This example shows what can be done with my technique. See how full and hairy this dog looks? Good contrasts (the balance of light areas against dark areas) are very important too. The trick is using the darks and lights together to create *shape* and blending to create *realism*.

As you go through the book, look at all of the illustrations carefully. See the pictures as *shape* first, then ask yourself, where is it dark? where is it light?

Since you will be working from pictures and photographs, remember that your artwork can be only as good as the picture you are working from. A tiny, blurred picture will not give you the information you need to do a good piece of artwork. Make sure you can see all of the details clearly. You cannot draw what you cannot see! For this reason, the picture should be fairly large (at least three to four inches).

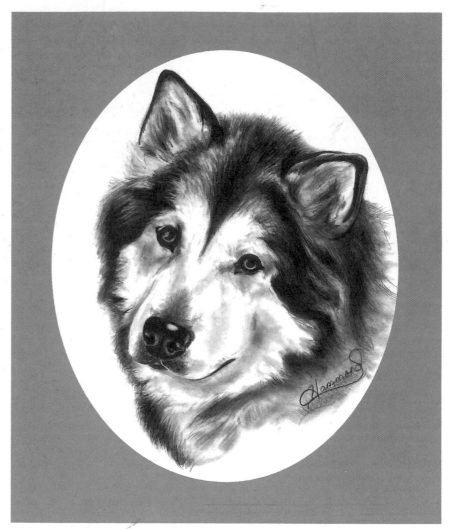

Portrait of a Husky
by Lee Hammond
9" × 12", pencil on Bristol

Note: This drawing is more than just a "sketch"; it is an actual portrait of this particular animal. See how the oval mat around it creates a professional look? You will be doing drawings like this in no time!

BEFORE & AFTER

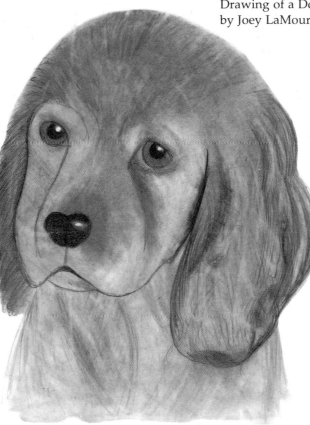

Drawing of a Dog (second attempt)
by Joey LaMourie, age 12

Drawing of a Dog (first attempt)
by Joey LaMourie, age 12

This drawing of a dog is good. It is drawn with good shapes, and a good understanding of what the dog looks like. However, it looks like a sketch, a quick fun drawing, rather than a finished piece of artwork.

This second drawing is more of a dog "portrait." The focus is now in the face of the animal, and the blending used in the fur helped make it look real. More attention has been given to eyes and nose (see the highlights?), which gives the artwork more of a finished look.

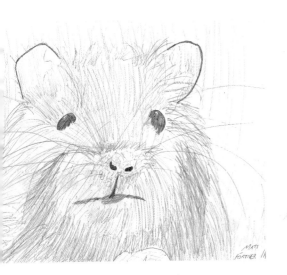

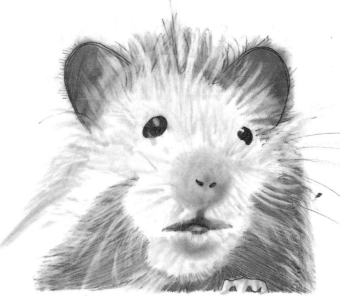

Drawing of a Hamster (first attempt)
by Matt Fortner, age 11

This is another example of a typical drawing done by a child. The artwork is made mostly of pencil lines, and has that "sketchy" appearance.

Drawing of a Hamster (second attempt)
by Matt Fortner, age 11

Once the secret to blending is discovered and the technique for "lifting" out the light areas has been practiced, the artist's eye develops. See how different the second drawing of the hamster appears? By applying these techniques, the hamster now looks real!

USING THE RIGHT MATERIALS

When doodling or sketching on your own, any drawing materials will work. Crayons, markers and colored pencils are fun, and the type of paper you use doesn't really matter.

But what do you use when you want to draw like a professional? You don't have to spend a lot of money to have quality materials, but you do have to have the right things! Here's what I recommend.

Drawing Paper

You need a smooth, heavy paper called Bristol. It comes in pads, and is terrific for shading and blending.

Pencils

I always use a "mechanical pencil." It has small sticks of lead in it, and you click the end of the pencil to push the lead out the tip. You put twelve pieces of lead in at once and they last a long time without ever having to sharpen your pencil. (Use 2B lead, because it's nice and soft and dark.)

Tortillions

What in the world is a tortillion? It is a cone-shaped thing made out of paper that you use instead of your finger for blending and shading. This is the "secret" to my whole technique.

Kneaded Eraser

This is a gummy, soft, squishy eraser that looks and feels like clay. You can mold it into lots of different shapes, and you can get neat effects by using it in your artwork.

Typewriter Erasers

These erasers look like pencils with a stiff brush on the end. They are good for erasing stubborn stuff off your paper, and for making "edges" nice and sharp in your drawings.

Pink Erasers

This is an all-purpose eraser, just like the one we used in school. Always have one handy.

A note about the different erasers. You will use the kneaded eraser the most. The pink eraser is for large areas, or for removing the graph lines you will be using. The typewriter eraser is used for "tight" areas, or for cleaning up edges. It is also good for dark lines that won't come up with the other erasers.

Ruler

To draw things in their right shape and size, we will graph and measure. There are many differ-ent types of rulers, so find one that feels comfortable to you.

Report Covers

These are shiny plastic sheets that are made for holding papers together. We will be making graph overlays with them.

Permanent Black Marker

This is what you need for drawing lines on your report covers.

Circle Templates (Stencil)

This is to help you draw perfect circles, which is very important when you are drawing eyes.

Magazines

This is your best source for practice material! Tear out pictures you may want to draw, and keep them in a file or large envelope. I collect pictures of *everything*, and separate them into different categories.

Coloring Books

Practice *drawing* the pictures, instead of coloring them in.

CHAPTER THREE

SHAPES

When drawing, it doesn't really matter what the subject is; the same principles will apply.

First, always see the thing you are drawing as a *shape*. What does it look like around the outside edges? How big is it? What about the inside shapes? How do they all fit together?

Next, how dark or how light are these shapes? Are they black, or are they white? Are they somewhere in between? If you can always remember *shapes*, *darks* and *lights* as you draw, you can *make it look real!*

Here are some fun exercises to help you train your eye to see just shapes. In the graph on the left, each of the boxes has a number and a pattern of light and dark shapes inside it. The graph on the right has empty numbered boxes. Draw the shapes you see in the boxes on the left into the corresponding numbered boxes on the right. (Example: Draw the shapes that you see in box #28 into the empty box also numbered 28.) Draw each shape as accurately and dark as possible. Don't try to figure out what it is you're drawing.

When you are finished, turn your work upside down and look at the image you created. You have just proven to yourself that

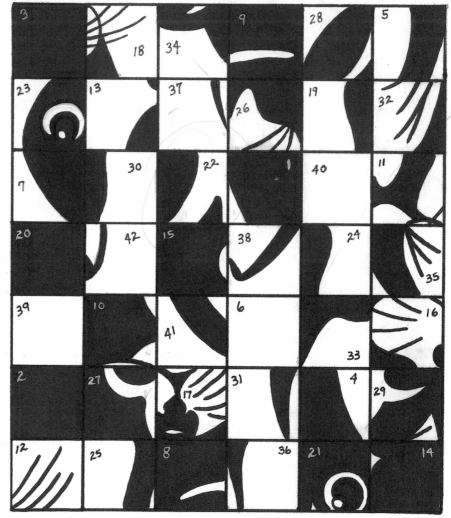

you can indeed draw! By not knowing what you were drawing, it was easy.

Remember this! Everything you draw from now on *must* be seen as puzzle pieces, all shapes connecting together to create a picture. All you need to decide is: What shape are the pieces? Are they light or dark?

These little drawings, or silhouettes, show you just how important *shape* is to the overall look of something. Even without any details, it's not hard to see what these animals are.

1	2	3	4	5	6
7	8	9	10	11	12
13	14	15.	16.	17.	18
19	20	21	22	23	24
25	26	27	28	29	30
31	32.	33.	34	35.	36.
37	38	39	40	41	42

You do not have to draw in the book. You can make photocopies to draw on.

If you are still having a hard time seeing what it is you just drew, here's a trick. *Squint* your eyes when you look at it. This blurs your vision and makes the lights and darks stand out more.

BAR GRAPH CHALLENGE

Here is another exercise to practice drawing shapes. Try to be as accurate as possible. Not only are the shapes in this one a bit more complex, it will also be harder to do for another reason. Why? Because you will now be trying to figure out what you are drawing as you go, won't you? This will only make it harder, so try to forget that it makes a picture. Just concentrate on the little shapes in each box. Let the shapes create the image for you!

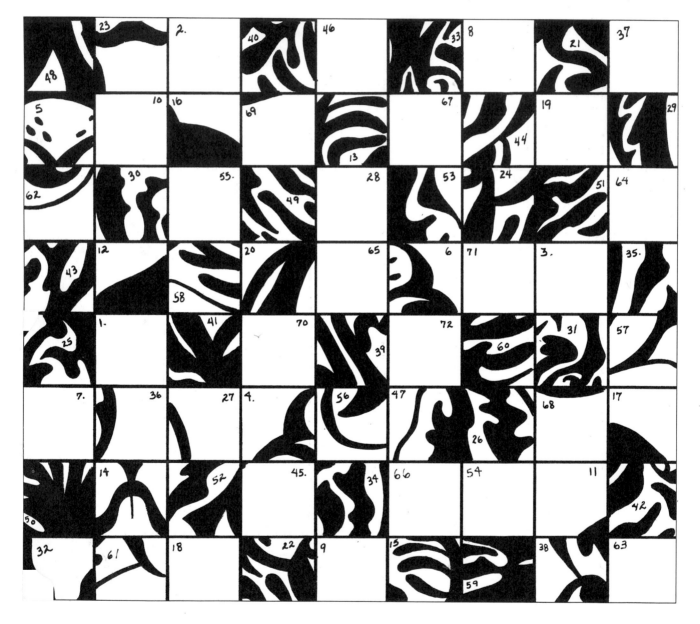

1	2	3	4	5	6	7	8	9
10	11	12	13	14	15	16	17	18
19	20	21	22	23	24	25	26	27
28	29	30	31	32	33	34	35	36
37	38	39	40	41	42	43	44	45
46	47	48	49	50	51	52	53	54
55	56	57	58	59	60	61	62	63
64	65	66	67	68	69	70	71	72

MAKING A GRAPH

Now that you see how everything is made up of shapes, you can draw anything you want. I know it sounds simple, but it's true! The more you practice, the easier it is to draw shapes correctly, and the better your art will become.

To help you draw from photographs, you can create graph overlays. They are easy to make by drawing boxes with a perma-nent marker on a clear acetate re-port cover. Have someone help you if you aren't very handy with a ruler. These lines have to be very, very straight, making the boxes perfect squares. Once they are done, you can slip a photo in-side, which will then turn your photo into a box exercise like the ones you just did.

Using a Graph Makes a Difference!

Using a graph may seem like "cheating." Try to think of it as merely another tool of the trade. Anything that helps you with the realistic portrayal of the thing you are drawing is just an "aid." Would you expect an architect to design a building without using a ruler to get the straight lines? It is

This is what a graph looks like when it is done. Make two, one with 1-inch squares on it, and another with ½-inch squares. The more details your photo has, the smaller the boxes should be on your graph. This helps you draw the "little" shapes better.

the same with your drawings. Why give an inaccurate representation of your subject, when you have the tools to make it look real? The real art comes with the finishing touches and your ability to render the details convincingly. Believe me, your graph will become your friend when you see the results you get. And, by using a graph, you will train your eye and improve your freehand skills.

Ringtailed Cat
by Kim Rosnick, age 12

This is what a student drew by looking at a magazine picture. It is a cute drawing, but it wasn't very accurate in size and shape.

Using the eraser and quick pencil lines for fur.

Blending creates the illusion of color.

By placing the magazine picture in a 1-inch graph, she was able to achieve the correct shape of the little ringtailed cat. (See the graph that was drawn on her paper as a guide?) After she got the shapes right, she was able to add some blending techniques and make it look real.

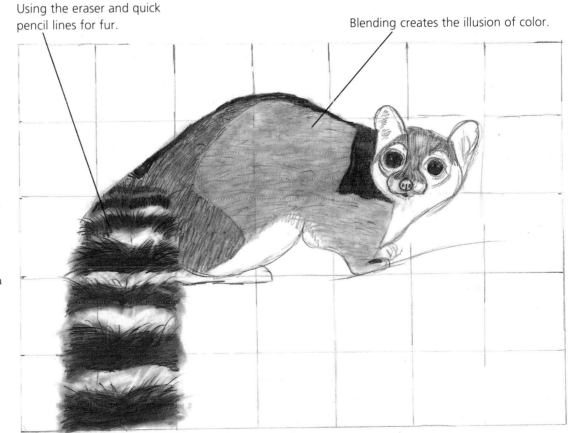

Ringtailed Cat
by Kim Rosnick, age 12

GRAPHING A DRAWING

Here is another practice exercise. Now that you are used to seeing and drawing just shapes inside each little box in the graph, you can try an actual picture of something.

Try your graphing skills with this simple line drawing. I have started the line drawing for you. You finish it! (Again, if you do not want to draw in the book, make a photocopy of this page.)

To give yourself more practice with simple shapes, take the graphs you made and practice drawing things out of coloring books. It will be just like drawing the squirrel, only now you will have to draw a light pencil graph on a piece of drawing paper.

When using a graph, you are not stuck drawing the subject matter the actual size. The beauty of these wonderful graphs is, not only do they help you get things accurate, they also help you reduce and enlarge your subject.

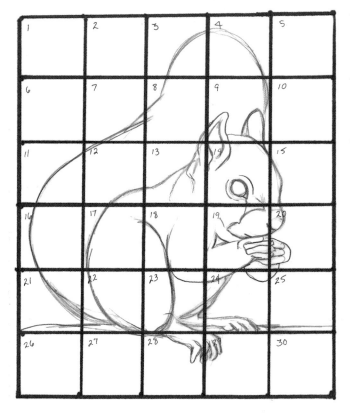

Note: Once you have drawn the squirrel and you are sure it is accurate in shape, remove the light graph lines with your kneaded eraser and save the drawing. Later in the book I will show you how to make it look real!

See what happens to the line drawing of the squirrel when I use bigger boxes on my drawing paper? The picture is enlarged. As long as you are using perfect squares, the shapes will always fit into the boxes the same way.

To reduce your picture, just make the boxes on your paper smaller than the ones on the graph over your photo reference.

GRAPHING A PHOTO

Seeing things as shapes helps us be more accurate. Using a graph helps us be more accurate. And here's one more thing that can help: drawing your subject upside down!

I know this seems silly. You may be thinking, "If it's upside down, I can't draw it, because it will look different from what I'm used to seeing." The truth is, *because* it looks different, you will be able to draw it *better*.

The photo of a dinosaur is fairly complex. By turning it upside down, you are forced to see it and all of its complexities as *just shapes*. When you are concentrating on just the little shapes and how they fit inside your graph, box by box, you can draw it more easily. It keeps you from thinking, "This is a dinosaur, and it is hard to draw." Keep it simple! Reduce it to just shapes!

Note: This photo is shown in the back of the book. Save your line drawing until after you have completed the assignments in the book. Once you learn the technique, you can get your line drawing out and finish it. Then you can make it look real!

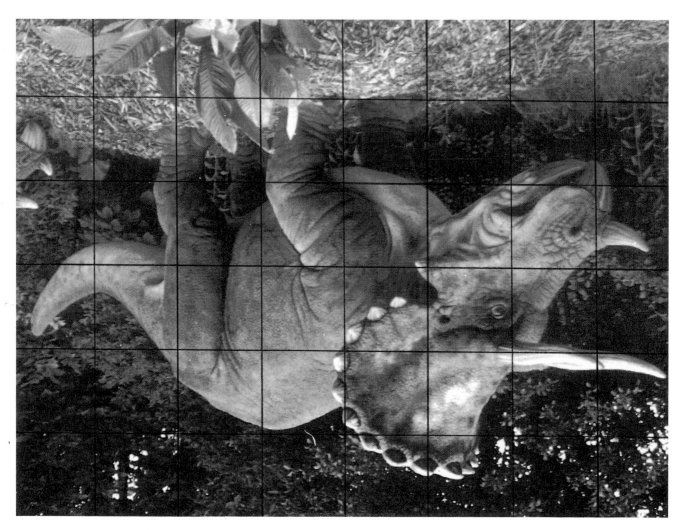

SHADING

Now that you are an expert on shapes, how do you *make them look real*? With *blending*! By giving your shapes lights and darks, you can create roundness, or "form." By blending these lights and darks softly together, you create *realism*.

This is an example of what good blending looks like. See how smooth it is? It goes from very dark to pure white, without any choppiness.

This is an example of poor blending and what can go wrong. It looks scribbled. There is no control of the pencil lines and it doesn't blend out at all.

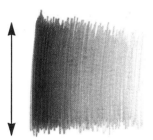

Always go up and down!

This is how to begin. Go up and down with your pencil marks, build up the darks a little at a time, until you get it almost black. Lighten your touch and move slowly to the right, making your pencil line lighter and lighter as you go. Keep your pencil lines very close together so they "fill in."

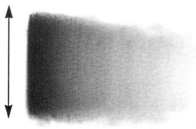

Never blend across! Always go up and down!

Now take one of your tortillions and blend this out. Start at the dark side and go up and down just like you did with your pencil marks. It will start to get smoother and darker. Lighten your touch and once again, move slowly to the right. Keep going until you are actually drawing with the tortillion and it

fades to nothing. If it starts to get shorter and looks like a sideways tornado, don't worry. That is normal!

Squint your eyes and look at your work. If you see little light areas or spots, take your pencil and gently fill them in to help it look smoother. If you see dark areas, take your kneaded eraser between your thumb and fingers and roll it into a point. Lightly "lift" the dark areas out, with the eraser's point.

Keep practicing the blending until you can do one that is very even and smooth. Don't move on in the book, until you feel confident.

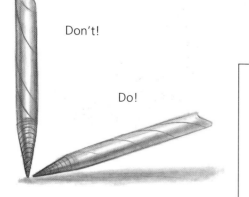

Don't!

Do!

A note about tortillions! Although they may look like pencils, they are just made of paper and are hollow inside. If you unravel one, you'll end up with a long piece of paper.

Tortillions merely smudge the pencil lines that are already on the paper. Don't worry if they start to get really dirty. Save them! Later on, when you are working a dark area on your drawing, you can use a tortillion that is already dark. For lighter areas, you can use a fresh one.

Always use these at an angle to keep from flattening the tip.

SHADING A SPHERE

There are five "elements" that go into shading. Each of these elements has a tone that matches the five-box value scale. Here is an explanation of each of them and where you can see them on the sphere.

1. **BLACK** This can be seen under the ball where no light can reach. It is called a *cast shadow.*

2. **DARK GRAY** This is the *shadow* on the ball. It is always on the opposite side of where the light is coming from. On this ball, the light is coming from the upper front. The shadow is seen around the lower side. See how the shadow makes the ball look round, by curving around it?

3. **MEDIUM GRAY** This is called a *halftone,* because it isn't light and it isn't dark. It is seen halfway between the light area and the dark area.

4. **LIGHT GRAY** This is the hardest element to see, but it is probably the most important one to have in your artwork. It is called *reflected light.* It is light that bounces up onto the ball from the table it's sitting on, and all of the light behind it. It can be found anytime you have an *edge,* or *rim.* It separates shadows from cast shadows.

5. **WHITE** This is the *full light* area. It is where the light is the strongest. It is where the white of the paper is left exposed.

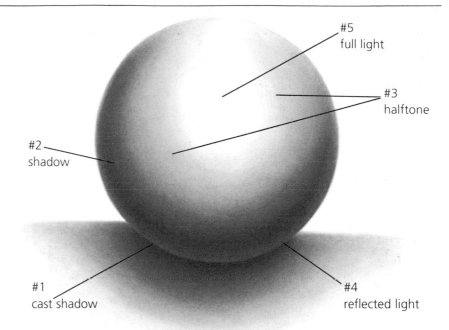

This is what good shading looks like. Without it, this would be just an empty circle. With shading, it becomes dimensional and looks like a ball. On this sphere, the light is coming from the front.

#1 black	#2 dark gray	#3 medium gray	#4 light gray	#5 white

This is called a value scale.

These dark areas should be "lifted" with the pointed edge of a kneaded eraser.

When you look at these examples of blending, squint your eyes! Can you see the dark areas that don't belong there? Can you see the light spots? These can be corrected with your pencil and eraser.

Light spots can be gently "filled" with the pencil.

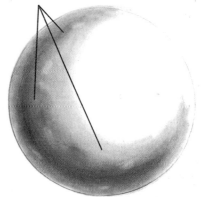

SHADING STEP BY STEP

Now it's your turn to draw a sphere. Start with an empty outline of a circle, and adding the five elements of shading, you can make it look real!

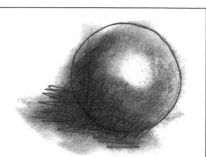

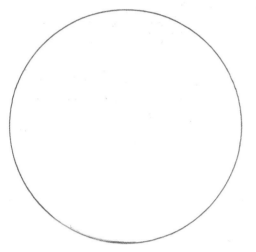

An empty circle.

This is what some beginning attempts can look like. Study carefully and you can see what *not* to do.

DON'T outline your circle. The beginning outline is always erased when you are done.
 DON'T use scribble lines. They can't be blended out. Always keep your marks very close together.
 DON'T get too dark too fast. This looks like a dark mess—there is no consistency and direction to the pencil lines. Always go "with" the shape of the object.
 DON'T lose the reflected light on the edge. There is nothing here to separate the shadow from the cast shadow.
 DON'T let your blending get uneven and out of control. Stay within the lines and let it fade gradually from dark to light. This looks too dark, and it looks like it has a hole in it. You can't even tell where the light is coming from.

A shaded ball, or "sphere." When blending, use your "dirty" tortillions for dark areas, but *always* use a clean one when going into a light area! Keep your tortillions separate and always have a fresh supply on hand.

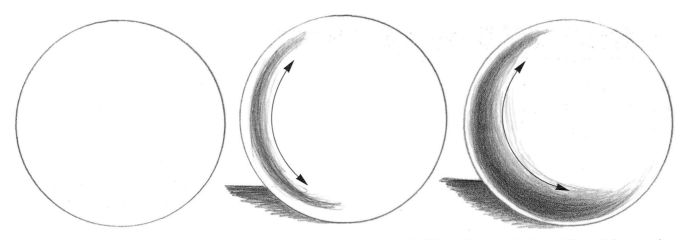

Start with the outline of a circle.

Place the cast shadow underneath. This should match #1 on your value scale. Place the shadow on the ball. It should match #2 on the value scale.

Blend with the tortillion, following the round shape of the ball. Follow the arrows and blend in the same direction that you placed in the pencil lines. Gradually get lighter as you move toward the light side.

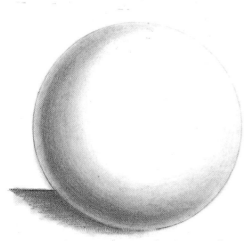

Blend some more until it is smooth. Don't let it get choppy! Squint your eyes to see the tones and if they are smooth. If not, "lift" the dark spots with the point of your kneaded eraser. "Fill in" the little light spots with your pencil. Lighten the original circle outline you drew.

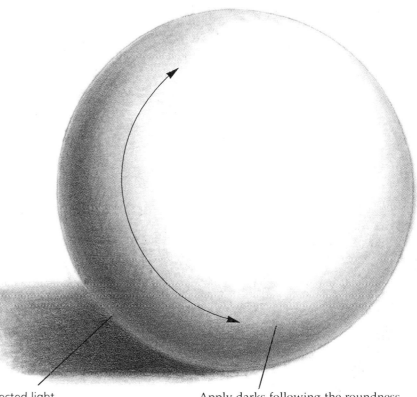

Reflected light

Apply darks following the roundness of the ball. Blend the same way.

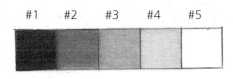

#1 #2 #3 #4 #5

SHADING SHAPES

In order to make it look real with blending, you must understand your subject's overall shape. Everything has what is called a *basic shape*. It is the general shape of something as a whole. Everything you draw will be a combination of the sphere and the four shapes you see here.

It will help you in the long run if you take some time to draw these, following the same procedure as you did with the sphere. Remember the five elements of shading and look for them on each shape. On all of these, the light is coming from the right. Follow the arrows when applying

your pencil and blend with the tortillion going in the same direction. Practice and really try for a smooth, even blend. Squint to see it better!

Study all of these drawings and you will *not* see a hard line drawn around any of them. Anything with a line around it looks like a

> Note: Look for the little rim of reflected light under all of these shapes. You will find it on the object just above the cast shadow. The elongated tube has no cast shadow drawn below it, but the reflected light is still seen along the edges.

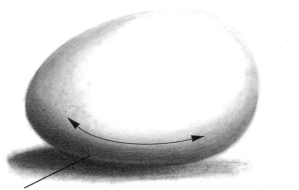

Reflected light The egg. Follow the arrows, following the egg's shape.

Look at the smooth blend on this illustration and see if you can create the same kind of blend as seen on these others. Remember the five-box value scale when placing your tones. Do not be afraid of a good solid dark.

Elongated cylinder or "tube." This shape is seen in legs and arms, snakes and more.

The cylinder. Place your darks up and down. Gently blend to the right.

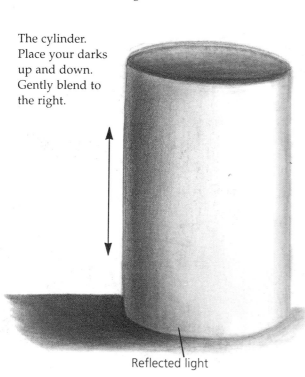

The cone. Follow the arrows.

Reflected light

Reflected light

cartoon! A close look will show you that the blending creates an "edge" instead of a line. Be sure to remove any lines from your work when you are done.

This illustration clearly shows how the basic shape of an egg can be seen in the mouse. Actually, it can be seen three times, once in the body, once in the head, and once in the ear. Following the same procedure as in the basic shape assignments, draw the mouse. Follow the arrows with your blending. Look for the five elements of shading. This will show you how easy it is to make it look real.

Since all animals are rounded, it helps to practice blending to create a curved shape. Can you see how a curved blend is seen in the mouse?

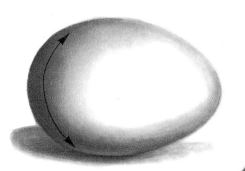

The egg shape can be seen in most animal forms, both in the body and in the head.

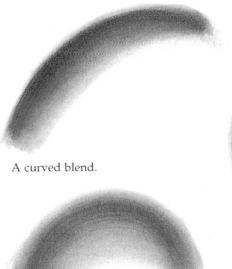

This mouse is made up of shaded, blended egg shapes. Look for the five elements of shading in this drawing.

The egg shape can be seen three times in the mouse's form.

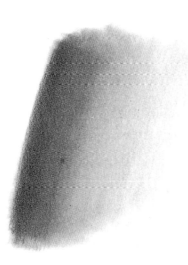

A smooth, gradual blend is essential for this style of drawing.

A curved blend.

An arched blend.

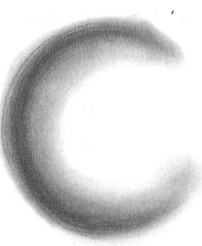

A circular, or spherical blend. Practice controlling the *shape* of your blending, while still keeping the tones even and smooth.

SHAPES IN ACTION

Always look for the *basic shapes* in the animals you draw. This simplified drawing of a kitty is really just a series of circles and egg shapes. Although it is somewhat cartoon-like, the addition of some blending helps make it look real. To give you some more practice with your blending, try drawing this freehand.

The egg shape is the most common basic shape found in animals. Look for combinations of egg shapes in other animals.

Note: Before you move to some big drawings, take note of these three things that must always be done to finish your work: (1) you must "clean" it up. Erase any and all smudges from around your work. (2) You should "sign" your finished work. You do not have to sign every practice drawing. Some people use both their first and last names, some use only their initials. You decide. (3) Be sure to spray your work with a fixative to keep it from smearing. Follow the directions on the can.

SHADING STEP BY STEP—SEAL

By combining the egg shape with a cylinder, you can advance to a more complex animal. This seal is a fun one to draw, and is a great lesson in blending.

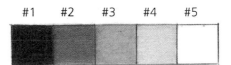

#1	#2	#3	#4	#5

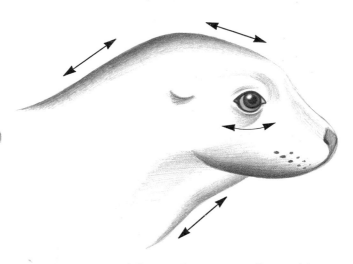

Place your graph over this drawing and lightly draw a graph on your paper. Lightly complete your line drawing, keeping the basic shapes in mind as you draw. The graph will help you place the eye and other features. When the line drawing is finished, erase the graph lines.

Gently apply shading following the arrows until you achieve the right tone. Complete the eye. It is a series of circles, one inside the other, each a different tone. Leave the little white spot, called the catchlight. It helps make the eye look shiny.

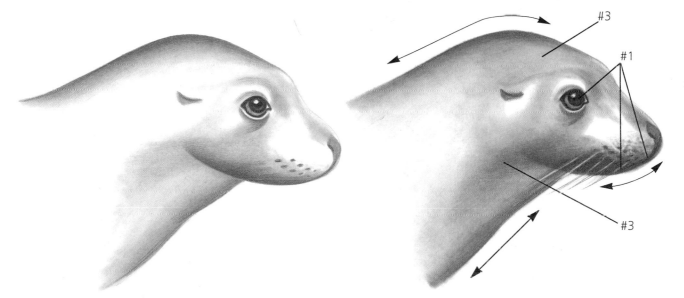

Blend with a tortillion from dark to light, following the same direction as your pencil strokes. Add more tone if it becomes too light. Then blend again.

Look closely at the seal's eye. Get the dark parts of the eye as dark as you possibly can. This is #1 on the value scale.

See how the whiskers are light against the seal and dark against the background? To get the light parts, squish the kneaded eraser into a "razor edge" and draw it across the shaded area of your drawing (see page 22). Where the whiskers are dark against the background, use your pencil.

SHADING STEP BY STEP—FLAMINGO

Now you're ready to advance to even more complex cylinder/ egg-shaped animals. Let's begin with this flamingo. Look closely at the textures of the feathers. Can you see how the light has been "lifted" off of the dark? (Just like the whiskers of the seal.)

Begin by using your 1-inch graph to draw the outline onto your drawing paper. When you are happy with the overall shape, remove the graph lines from your paper with the kneaded eraser. I will show you how to add the blending, shading and details to make it look real!

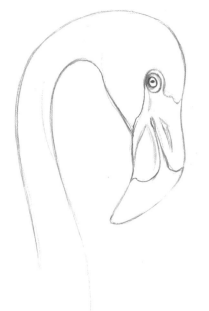

The basic line drawing done using a 1-inch graph.

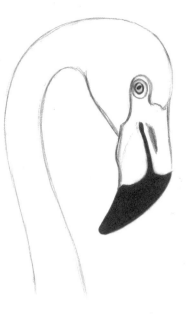

Apply your #1 darks to the beak. Make sure that your tone is very smooth.

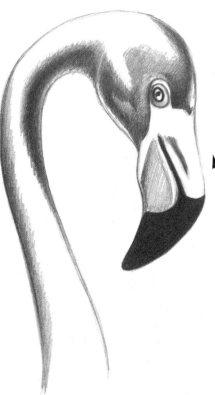

Apply shading, paying attention to the value scale, just like the sphere exercise.

Blend everything out to a smooth tone following the arrows.

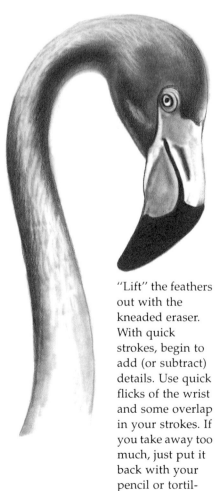

"Lift" the feathers out with the kneaded eraser. With quick strokes, begin to add (or subtract) details. Use quick flicks of the wrist and some overlap in your strokes. If you take away too much, just put it back with your pencil or tortil- lion.

BIRD

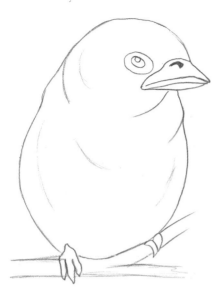

Use your graph to obtain this outline.

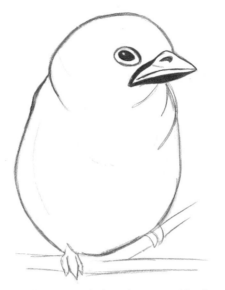

Apply your #1 dark to the eye and beak.

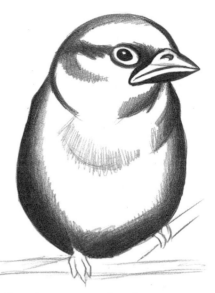

Follow the arrows and apply your tone for shading. This ranges from #1 to #3 on your value scale.

Note: When lifting with the kneaded eraser, you must create a fresh edge after every two or three strokes. This keeps the eraser clean and the edge sharp. To clean your eraser, just play with it. Keep squishing!

#1 #2 #3 #4 #5

This little bird looks basically like a feathered egg.

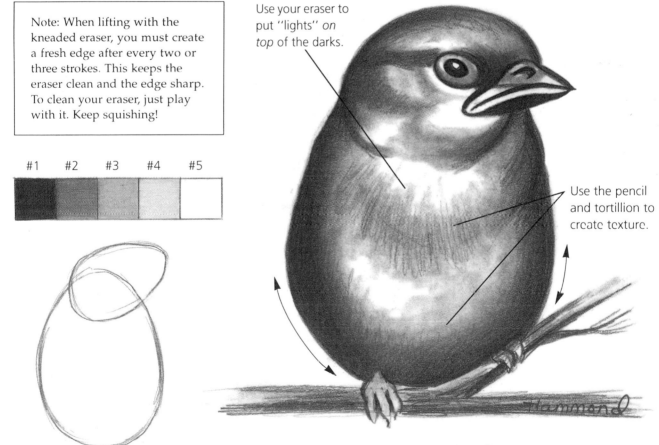

Use your eraser to put "lights" on top of the darks.

Use the pencil and tortillion to create texture.

Blend until smooth. With your pencil and tortillion, create a little texture. Use the lifting method to make those light areas look like they are "on top" of the dark areas.

SHADING STEP BY STEP— POLAR BEAR

When you draw with pencil, you are creating the illusion of color with various shades of gray. But what you may not realize is that nothing is one pure color or tone because of the way light affects it, especially with the drawing of animals. Their fur is an assortment of gray tones.

Look at this polar bear. You may be tempted to draw a line around him for shape, and then leave the bear white, since a polar bear is "white." But he is really different shades of gray with light areas "lifted" out. By shading a gray background behind him, his light fur stands out without having to use a line around him.

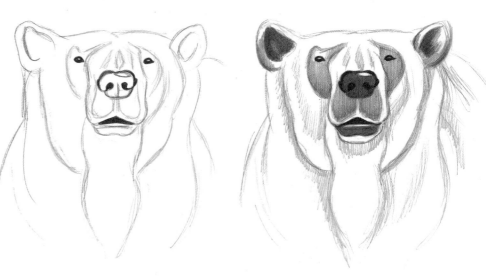

Start with an accurate line drawing. See the bear as shapes. Apply the #1 darks to the eyes, nose and mouth areas.

Apply the #2 darks to the lower lip and inside the ears. Apply the #3 tones around the eye area and around the ears. Notice how the pencil lines are going the direction that the fur is going?

#1	#2	#3	#4	#5

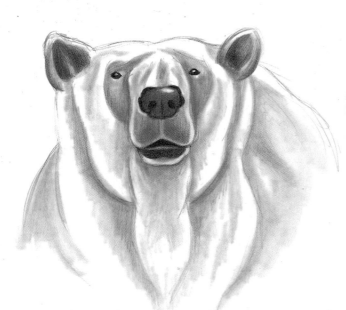

Blend to make him look soft and smooth. Don't let your tones get too dark, or he won't look white anymore.

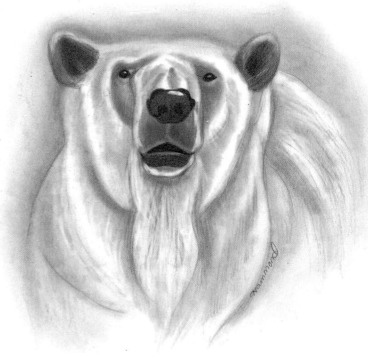

Create some textures in the fur both with your pencil and tortillion. Lift some highlights with the kneaded eraser to keep the light on top of the fur where it belongs. Keep it looking soft!

Now, with your dirty tortillion, blend some gray tone behind the bear. Remember that in order to have a "light" area, you must have a darker one to make it stand out.

LABRADOR RETRIEVER

Now that you understand the principles of drawing something light, let's do the same for something dark. Just as white is not really white, black isn't just black either! In this photo of my dog Tippy, you can see that she is about as black as an animal can get. But, because of the lighting, she has highlights in her fur. Study the photo and the drawing. You can see the light areas where the sunshine is hitting her. You can see how important it is to get good and dark with your pencil. My most used comment in my drawing class is: *Get it darker!*

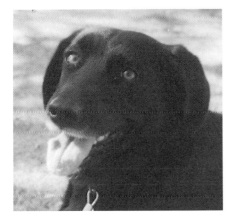

An accurate line drawing. Look carefully to see how every tone created by the lighting has been assigned a shape. I like to think of this as a "puzzle-piece theory" with each shape connecting to another. The more complex your subject or lighting, the more "pieces" you will have to draw in. This is where a graph is mighty handy.

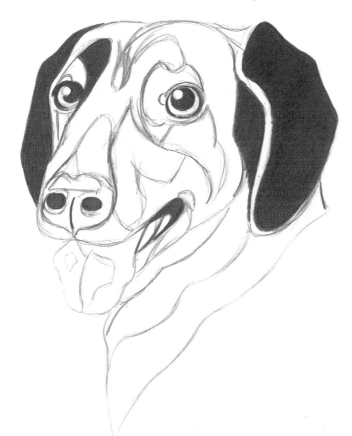

Apply your #1 darks as shown. Be sure that these areas are as dark as you can get them! This drawing will take more time than something that is white, like the polar bear.

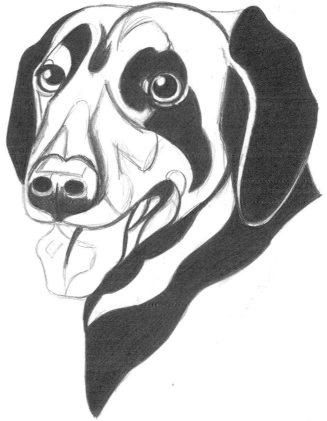

Continue placing #1 darks. Again, be sure to get them nice and dark. Go over them as many times as necessary until your pencil lines no longer show.

Now, apply the #2 darks as indicated. Try to keep your pencil lines smooth. Apply #3 dark to the tongue area.

Note: See how you can use the photos out of your family album for inspiration? You don't have to draw the whole picture; just a select part of it can make a nice drawing.

#1	#2	#3	#4	#5

Start to blend the tones together so it has a smooth even finish. If blending starts to make it look too light, just re-apply the darks and blend again. There is no limit to the times you can go back and forth.

TURNING COLOR INTO BLACK AND WHITE

This is what a color photograph looks like when you put it through a black-and-white copier. See how the various shades and colors are represented in the black-and-white version.

Remember how the shading behind the polar bear helped make him stand out? The lighting of this photo makes it necessary to do the same thing here.

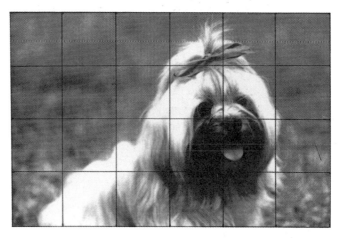

Once you have used your graph to get the line drawing, apply the #1 dark areas. Because this dog has long hair, you need to apply the darks in the direction that the hair is going. This will help you replicate the illusion of hair.

Also use pencil lines to place the #2 darks. Follow the hair direction!

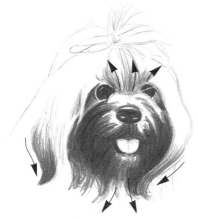

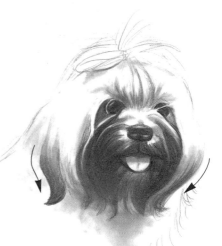

Take your tortillion and gently blend it out, going the same direction as when you placed the pencil lines. Use blending to place some tone under the chin.

With a dirty tortillion, add shading behind the dog to make the light of the hair show up. Add the bow to the hair to make her look "cute."

The finished doggie portrait.

FACIAL FEATURES

EYES

Facial features are very similar from person to person. Not so with animals! They are all different and you must carefully study details that you normally would overlook. Each animal species has its own set of characteristics and differences.

Look at the eyes on this page. Each of them belongs to a different animal group.

The procedure for drawing the eyes is the same regardless of the species. Follow the directions on the next page for drawing the eye of a deer. When you have completed it, take the line drawings of the other species and render them yourself, using the same guidelines. Since everything should be seen as just shapes first, I've drawn the "puzzle piece" version of the eyes to help you get started.

This is the eye of a reptile. See the pupil (the black spot in the middle of the eye)? It is more of a slit than a circle. Of course, the size of the pupil depends on how much light is hitting it.

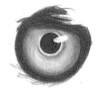

This is the eye of an owl. See how round the eye is? Use the circle stencil to draw this eye.

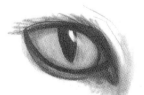

This is the eye of a cat. It has a slit for the pupil, but it changes from very round to very thin depending on the light.

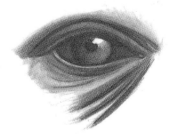

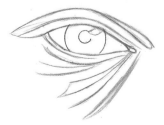

Nope, this isn't the eye of a person, although it sure looks like it! This is the eye of a gorilla. One of the biggest differences is that the "white" of the eye is dark instead of white like ours. Also the eyelashes aren't as noticeable.

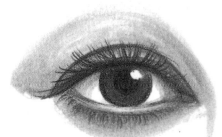

We are all fairly familiar with what the human eye looks like, but you will see many differences in the eyes of animals. The size and shape will differ from those of a human, and often there is no eyelid to be found. Also, the "white" of the eye is rarely white in the animal kingdom.

Note: In all of these eyes, do you notice the little white spot that is partially in the pupil? This is called a "catchlight." It is where the moisture of the eye is reflecting light. Without this, the eyes would not look wet and wouldn't sparkle.

This is the eye of a deer. Its eyes are on the sides of its head, and the pupils are wide and oval. Start with the basic outline or accurate line drawing. Look at the many ovals seen in this eye.

Fill in your #1 and #2 darks.

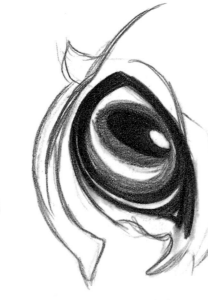

Add the eyelashes with very quick strokes. Be sure to keep them soft looking, not harsh. This requires a light, quick stroke. (You will learn more about that a little later, so keep reading!)

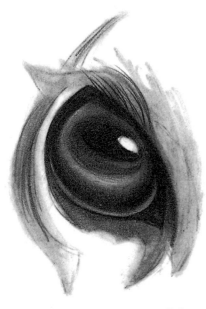

Blend out the gray tones until they are smooth. Blend around the outside of the eye.

DRAWING NOSES

This rabbit nose has a very distinctive shape and is easy to capture in a line drawing.

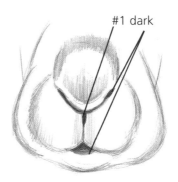

#1 dark

Apply tone (#3 on the scale). Notice how the pencil lines are going in the direction that the fur is growing.

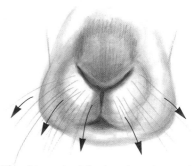

Blend to make it look soft and rounded. Apply the whiskers with your pencil, using very light, quick strokes.

This dog nose is also easy to draw in line form, but the shading is more complex than the rabbit nose. Use a graph. Assign each tone a shape. This is called "mapping." This nose is wet, so it's important to show the glare of light reflecting off the wet surface, like the catchlight seen in the eyes.

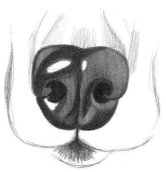

Fill in shading according to your map. These are mostly #1s and 2s on the scale.

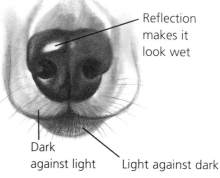

Reflection makes it look wet

Dark against light

Light against dark

Blend it out with your tortillion. Apply the whiskers with your pencil. There are some light whiskers on the chin area. These are lifted out with your kneaded eraser formed into a chiseled razor edge.

Although this gorilla's nose is not wet like the dog's, it is shiny. Be sure to leave a lot of white areas to look like reflected light. I think if you look very closely, you will be able to see all five elements of shading in this one.

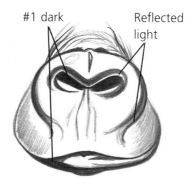

#1 dark Reflected light

Begin to apply tones. Above the nose is a wrinkled area. This is achieved with the pencil and curved lines.

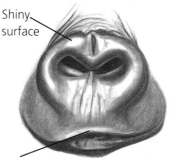

Shiny surface

Reflected light

Blend. Be sure to create the look of a shiny surface by leaving light areas.

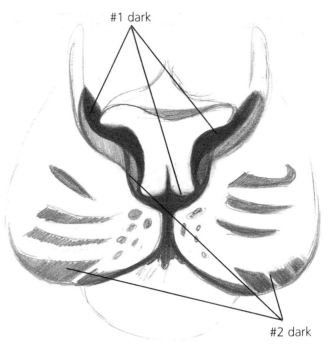

Here's a tiger's nose. It has the same basic shape as other cats', including domestic kitties'. Begin with an accurate line drawing of the "puzzle pieces"; use a graph to draw accurate shapes.

Apply tones. Because of the stripes, this nose has areas of extreme light and dark.

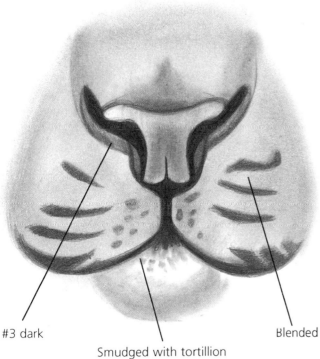

Blend.

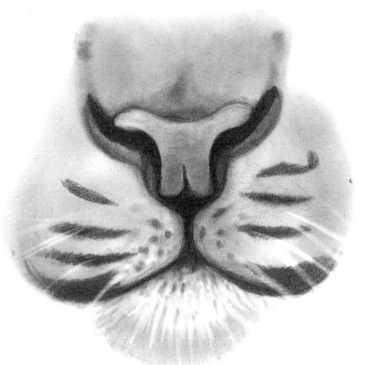

Lift out the whiskers and small hairs in the chin with a kneaded eraser.

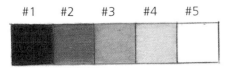

HAIR AND FUR

So far you have studied the different shapes of animals and the differences in their facial features. Now it is time to carefully study their hair and fur. When drawing hair and fur, you can *make it look real* by using your shading and blending, so the formula will be very much the same as before. The difference will be the addition of pencil strokes to mimic the look of hair and fur.

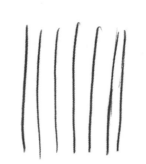

This is an example of what *not* to do! These lines are too hard and too straight. To draw hair or fur, you *must* use a quick stroke, one that will become lighter and tapered on the end.

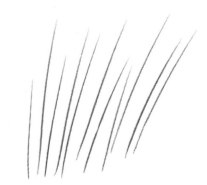

This is what tapered lines look like. By flicking your wrist as you draw, the lines will soften at the end. Also, there is a slight curve to them, which also makes them look softer.

To draw long hair, apply quick strokes, always going in the same direction that the hair is growing. Keep applying until it "fills" and becomes the color you want. Notice how some of the hairs start to overlap one another?

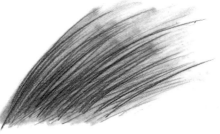

Blend it all out, still following the direction of the hair growth.

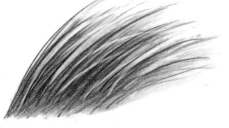

With a razor edge on your eraser, lift some lighter hairs out. This is what makes the hair look like it is in layers and has fullness.

Short hair is done the same way, only with shorter strokes. A quick stroke with the pencil is essential!

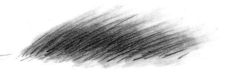

This is what light, smooth fur would look like (like the polar bear). It is drawn mostly with a dirty tortillion instead of pencil. The look of individual hairs is not as visible. Again, lift the lighter hairs out with the kneaded eraser.

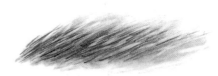

When the hair or fur doesn't look right, it's usually because the artists gave up before they were really finished. Devote the proper time to the rendering of hair—it *must* be built up in layers!

SHORT HAIR

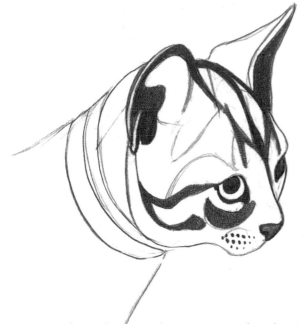

Use a ½-inch graph to complete an accurate line drawing. Look at the patterns the lights and darks are creating in the fur. Draw them in as shapes. When you are happy with the outline, remove your graph lines. Apply the darkest darks as indicated.

Apply the gray tones in the proper places. Look at these areas as puzzle-piece shapes that all fit together.

Blend out the grays until smooth. Leave the light areas light. Add some smooth gray to the eye with your tortillion.

Add quick strokes to imitate the look of fur, and add the whiskers with quick, tapered lines. Put your eraser to work, lifting out little white hairs. Experiment, using your pencil lines and eraser together to make it as furry as you want.

With your kneaded eraser in a point, gently lighten the color of the eye and pull out a highlight to make it look shiny.

SHORT FUR

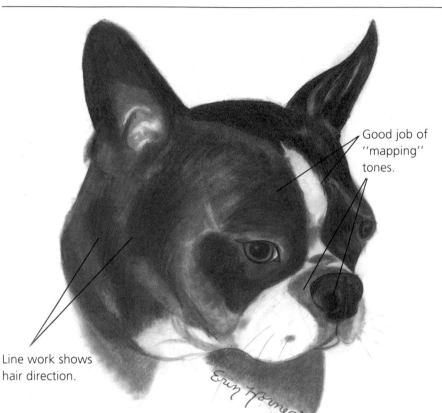

Good job of ''mapping'' tones.

Line work shows hair direction.

Drawing by Erin Horner, age 10

This is a good example of short, dark fur. This student drew the overall shape first and did a good job of ''mapping in'' the puzzle-piece shapes and assigning them a tone.

To give you inspiration, here is some work done by my ''younger'' students. They have proven that the procedures work.

This is short fur too, but it is very light and even in color. Even blending gives the hair smoothness and creates the shape of the dog.

Good, smooth darks and application of catchlights.

Drawing by Kari Gruber, age 14

LAYERED FUR

Good understanding of eyes—shows direction, shape and shine.

This is a good example of a student taking the necessary time to achieve the look she wanted. In doing a close-up of this fox, it was important to show the individual hairs. To do this effectively, it was important to keep the line direction following the hair growth and to keep building up the layers. By blending, and then adding the hairs with the pencil, she was then able to use her kneaded eraser to help with the layered look. The results were soft and smooth, but definitely hairy!

Note: All of these kids did a great job! Go through books and magazines and file different pictures of animals to draw from. Follow the "formula" and you too can make it look real!

Drawing by Sarah Burkhardt, age 12

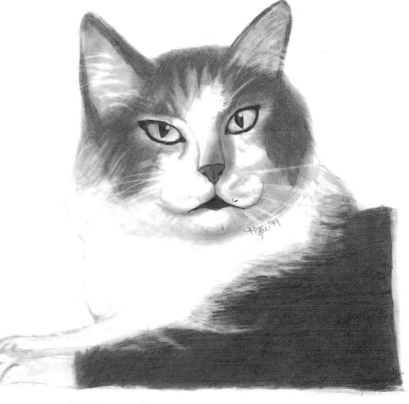

What more could you ask for? This is a combination of long and short fur and black and white, all mixed together! When you have more than one color on an animal, you make the colors work together so they don't look separate. By pulling the white fur of this cat "into" the black areas with the eraser, the artist has made the cat look fluffy and furry. Also, look how the white whiskers were "lifted" out. And, how's this for inspiration? This artist was only ten years old!

Drawing by Katie McGee, age 10

Now that I have inspired you with what other people have done, it's your turn to shine! Go back and grab the graphed line drawing of the squirrel that we did in chapter three. It's time to make it look real!

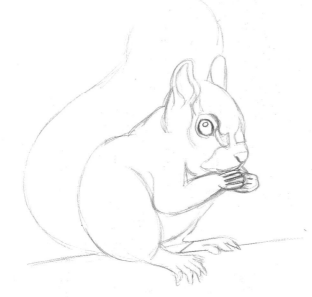

Make sure that your line drawing is accurate before you begin. You have had a lot of practice since we first started, and you probably are better at drawing now! Check to see if there is anything you would like to change. When you are satisfied, move on to the next step.

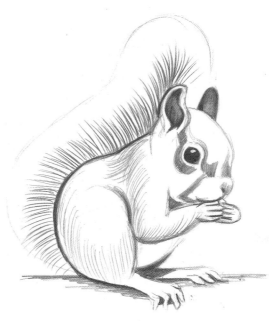

Fill in the eyes, except for the catchlight. Apply tone to the ears and face. Begin the process of filling in the hair direction. Use quick strokes.

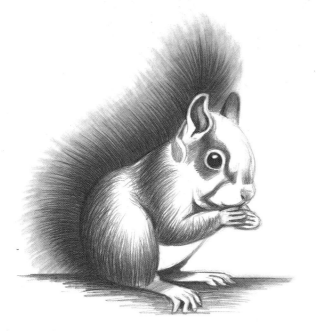

Keep applying hairs to the tail until it fills in. When it seems fairly full, blend the whole thing out. Keep building up the tone in the body. Apply some dark under the squirrel; use rough pencil lines to look like wood.

Blend out the body of the squirrel, and the face and tummy. Use the razor edge of the kneaded eraser to soften the edges of the tail and create lighter hairs in it.

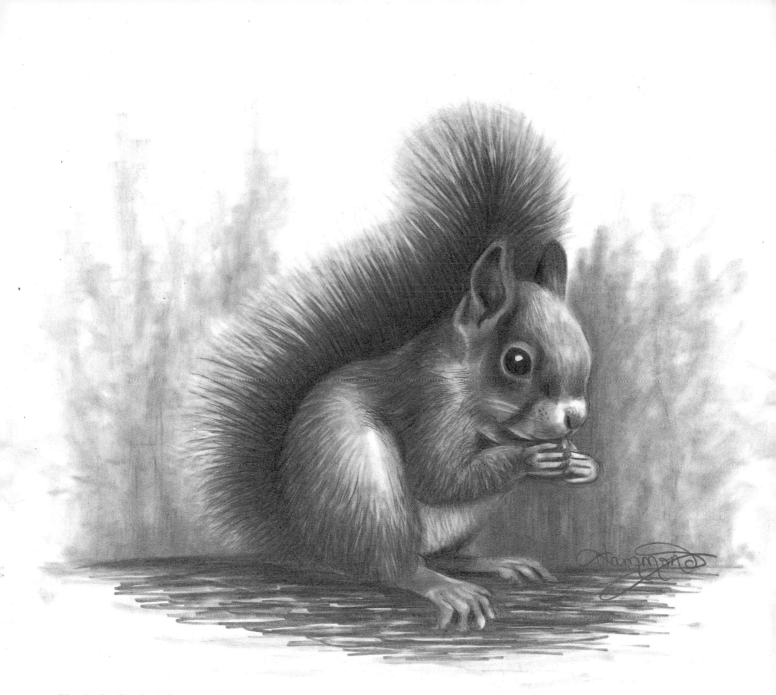

Here's the finished drawing. Can you see how the background has been created by smudging with a dirty tortillion? By making the background soft and out of focus, it gives the illusion of trees far in the distance.

PUPPY HAIR

Here is another photo to work from. Compare it to the drawing I did from it. Can you see the difference? I changed it a little bit by leaving out the back of the dog. Sometimes what looks good in a photo will not look good in a drawing. Good ol' artistic license!

#1	#2	#3	#4	#5

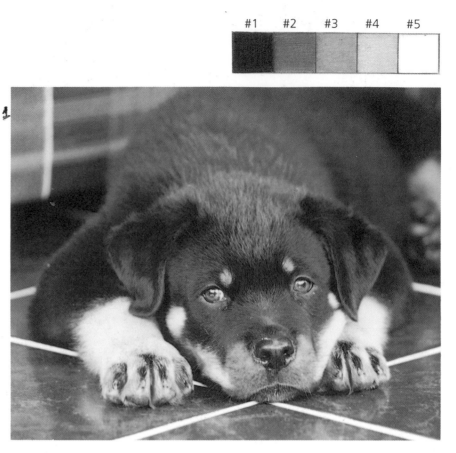

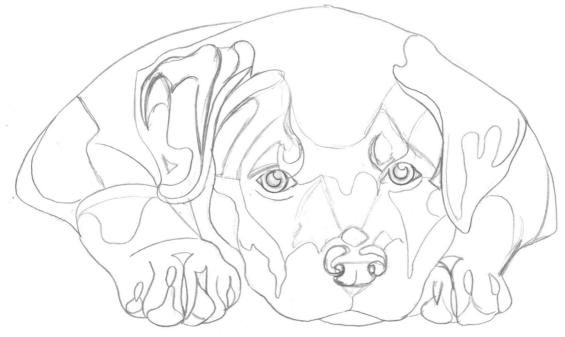

Use your graph to achieve this line drawing. Graph from the drawing, not from the photo this time (since I changed the drawing a little). Notice all the different shapes created by the light reflecting off this black fur. Another good example of black not being black!

Apply all the areas that appear to be a #1 dark.

Apply your other gray areas, which are #2 and #3.

Note: Go through your family photo albums and see if you have any good "pet pictures" that you can draw from. Remember, if you still feel more comfortable working from black and white, you can have black-and-white copies made of your color photos. It can be a lot of fun to take your pet's picture and make it look real!

Blend everything out to give the illusion of soft fur. Smudge some tone below and beside the dog to make it look like he's lying on something.

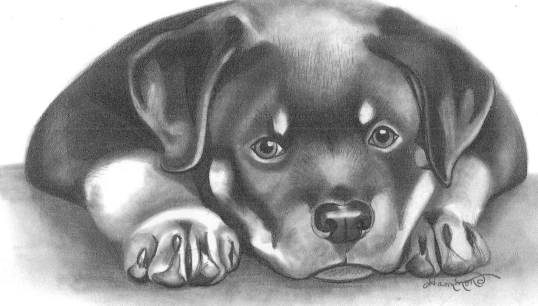

SHAGGY HAIR

Start with an accurate line drawing. When drawing something this small, it will be helpful to use your ½-inch graph.

#1	#2	#3	#4	#5

Apply the pencil lines in the direction that the hair is going. Fill in the nose and eyes with #1 darks. Use quick, curved strokes to help create the form of the dog. Be sure to leave the catchlights white!

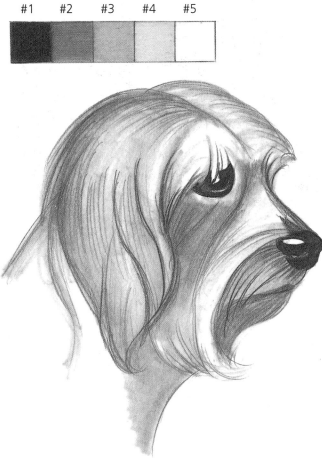

Blend everything out to a smooth gray tone. Blend in the same direction as the pencil lines.

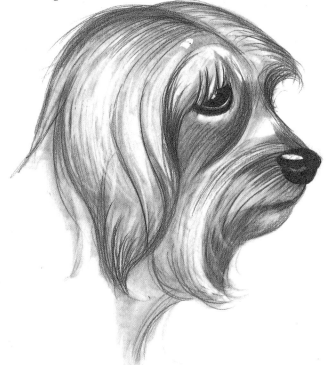

With your kneaded eraser in a razor edge, use quick strokes to "lift" out the long hair. Use the back and forth process of lifting lights and reapplying darks until it looks shaggy and full. Be sure not to stop too soon!

Now try some *really* long hair and some curly hair. Ask yourself these important questions as you draw.

1. What direction is the hair going?
2. Where does the hair start?
3. Where does the hair end?
4. Where is it blended?
5. Where is it dark?
6. Where is it light *over* dark?
7. Is it smooth, or should obvious pencil lines show?
8. Where are the dark areas and the highlight areas?

On the lion, the hair direction is easy to follow, but the dog has curly hair on top. It was done with circular blending with the tortillion and circular marks with the eraser. The highlights are found anywhere the hair is curved and rounded.

Note: By now you are probably thinking that this is all very repetitious, right? That's good! It proves that the same process is used for everything you draw. And now that you know the process, well, there's no end to what you can draw! Have fun!

Apply quick pencil strokes following the hair's natural curve.

Blend out with the tortillion. Create curls and wisps.

Lift curly layers out with the eraser.

MORE HAIRY CRITTERS

Here are two animals with wispier hair. Study each of these examples before you attempt to draw them and look for these things:

1. See how light hairs are lifted out of the dark areas?
2. See how the pencil lines go in the direction that the hair is growing?
3. Can you see the *basic shapes* within the animal's form?
4. Can you see how the formula has been used? (Look for line, blending and lifting.)

Both of these critters have fur that is very "hairy" looking. It will be important to let the pencil lines create that look for you. Again, use a quick, tapered line and fill it in. Don't give up too soon. It takes time to get it to "fill." Use a razor edge on the eraser to "lift" those light hairs. This is what makes the layered look.

Both of these have very round eyes! Use your circle stencil.

Drawing of a raccoon. Quick dark pencil lines give the illusion of hair. The quick, light strokes make it look even hairier.

"Otto." Drawing realistically does not mean that you cannot have fun! I thought that this otter would look cute "dressed up." Be creative and feel free to make your drawings look more imaginative.

On the otter, the hairs are longer and wilder. Use some dark lines and lift the light ones for good contrast.

TEXTURES

You now have experience drawing various types of hair and fur. But what about all the animals that have no hair? Some are smooth, some are wrinkled. Some have lines and scales. You will see that the same approach used to create "hairy" animals can now be applied to the "hairless" varieties.

I like this photo because of the lighting and the way the shadows look on the elephant. I have placed a ½-inch graph over it. The line drawing shows you how you can use the graph method to enlarge the subject. By making the boxes on my drawing paper *one inch*, I was able to draw the shapes *twice* the size of the photograph. By drawing the shapes just as they fit within each box, the de-

tails are enlarged. You could also *reduce* your subject matter by making the boxes on your paper *smaller* than those on the photo.

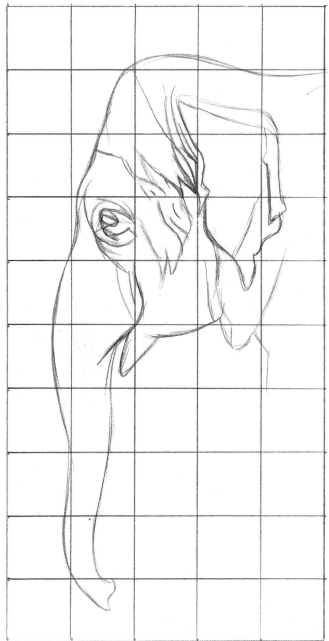

You can use the graph method to enlarge your subject matter. This line drawing is *twice* the size of the photo.

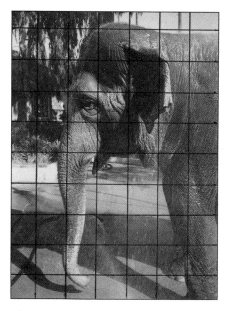

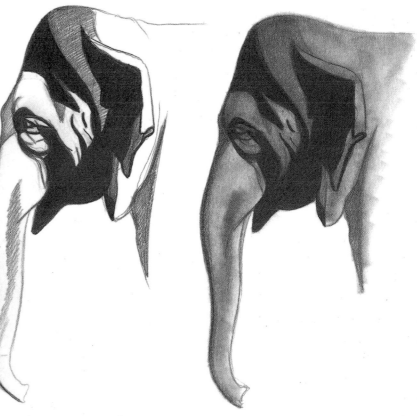

Once you have an accurate line drawing, you are ready to apply the darkest darks (#1 on the value scale). Be sure you have drawn in all of the light and dark areas as shapes, like puzzle pieces.

Add the gray tones where indicated.

Blend everything out until smooth.

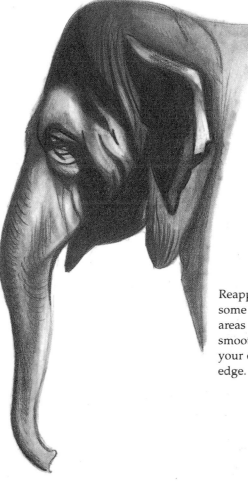

When drawing from photos, you must be sure that they are good enough to work from. Be sure that the subject matter (the thing you are drawing) is big enough to draw from. You cannot draw what you cannot see! Also be sure that it is clear and has good contrasts (areas of light and dark). Remember that if a photo is bigger than you want your drawing to be, you can reduce it by placing a 1-inch graph on the photo and a ½-inch graph on your drawing paper.

Reapply some of the dark areas, adding some wrinkle lines. Lift the highlight areas out with your eraser. Since he is smooth and doesn't have hair lines, use your eraser in a point, not a chiseled edge.

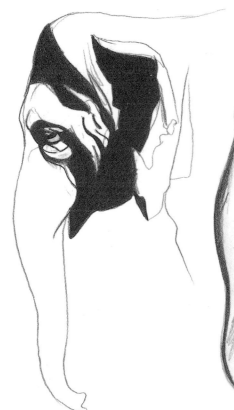

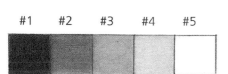

#1 #2 #3 #4 #5

COMBINATION SKIN

Drawing of an Elephant
by Erin Horner, age 12

This example shows the importance of good darks and even blending. The texture of the ears and trunk has been achieved with good use of line. Creating a cast shadow under the elephant gives it solidity and keeps it from floating on the page.

Elephant

Here is another example of an elephant, done by a young student of mine. What a wonderful job of blending she did on this to achieve the right color of gray.

The use of lines in the trunk area gives the illusion of wrinkles. And the lifting of light areas in the face and ears really helps make it look real! By adding some grass under the feet, it looks like the elephant could walk right up to you!

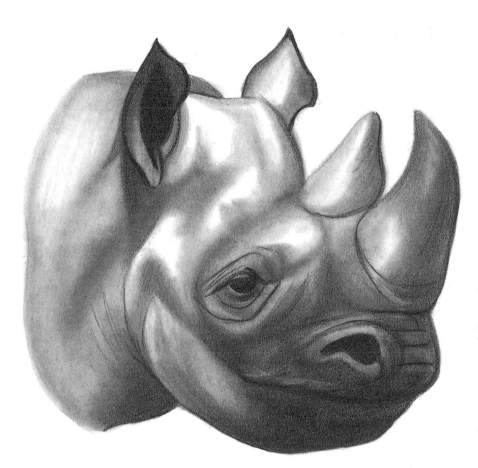

Rhino

Use your graph to get the outline of the rhino. Look at the light and dark patterns on him and include these in your line drawing. Draw them in as *shapes*. Most of the darks are on the underside, and most of the lights are on the top. This means that the light is coming from the top (shadows are always opposite the light source).

Look for the egg shape in the shape of his head and the cone shapes in the horns. Once you're sure your line drawing is right, erase the graph and follow these steps to make it look real!

Apply all of the dark areas with your pencil. Blend everything out to a gray tone (go from dark to light). Reapply some of the darks. Blend to soften. Lift the light areas with the kneaded eraser that's pinched to a point.

Goldfish

This little goldfish is also a good example of something that has different textures in it. It is drawn very smooth, but after you are finished blending, you use pencil lines to create the look of scales. The kneaded eraser is used to create the shiny glare.

Scales are made last with light pencil lines.

Glare is created with the eraser.

SMOOTH SKIN

Dolphin

A dolphin is a great example of smooth, shiny skin. This goes for many of the water-living creatures. Here are a few to test your blending skills.

This dolphin shows how you can dress up a drawing using a "graphic" look. This is fun and helps the artwork look finished, not "floating" on the page. It makes it look dimensional, like it's coming toward you. Again, look at all of the darks and lights. See how the light areas have been "lifted" to help make the dolphin look shiny?

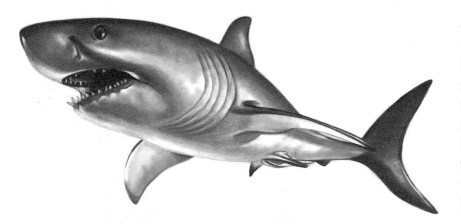

Shark

Study the shark and the effects of the light on it. Can you see that the light is mostly coming from the bottom and the extreme dark areas are found along the top? Pay close attention to how the fin on the right side overlaps the side of the shark and appears to be coming forward. Be sure to keep your blending extremely smooth!

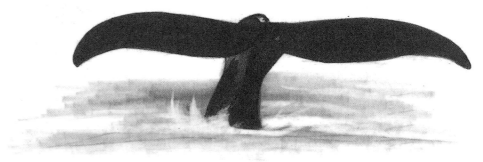

A Whale of a Tail

You do not have to draw everything in full form, as witnessed by this drawing. Even though it is just "part" of a whale, it is still a fun drawing.

SCALY SNAKE

The application of scales, as in the drawing of the goldfish, can also be seen in this snake. The blending always comes first, to establish the actual color of the snake. The scales are drawn on top, as the finishing touch, along with any highlights that may need to be lifted.

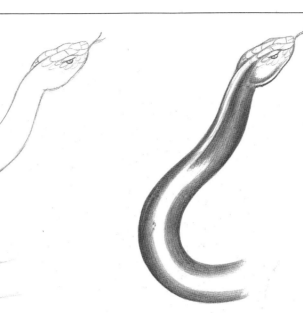

Step 1
Line drawing. This is an egg-shaped head and a cylinder body.

Step 2
Shading.

Step 3
Blending.

Step 4
Add the details.

COMPLEX TEXTURES

Some animals can be downright complex! These reptiles sure prove that. Study them carefully and you will see that they, too, are blended first and detailed later. Concentrate on *shape* first! If the shape isn't accurate, nothing you do to create texture is going to make it look right.

The small doodles show you the type of lines required to achieve the textures. Just like when you were drawing hair, be sure to devote enough time to it. Drawing to make it look real is not a quick process.

The texture on the side of the alligator is created with the use of crisscross lines, called crosshatching.

Crosshatching is also seen on the iguana. Circular lines are seen on its face and neck.

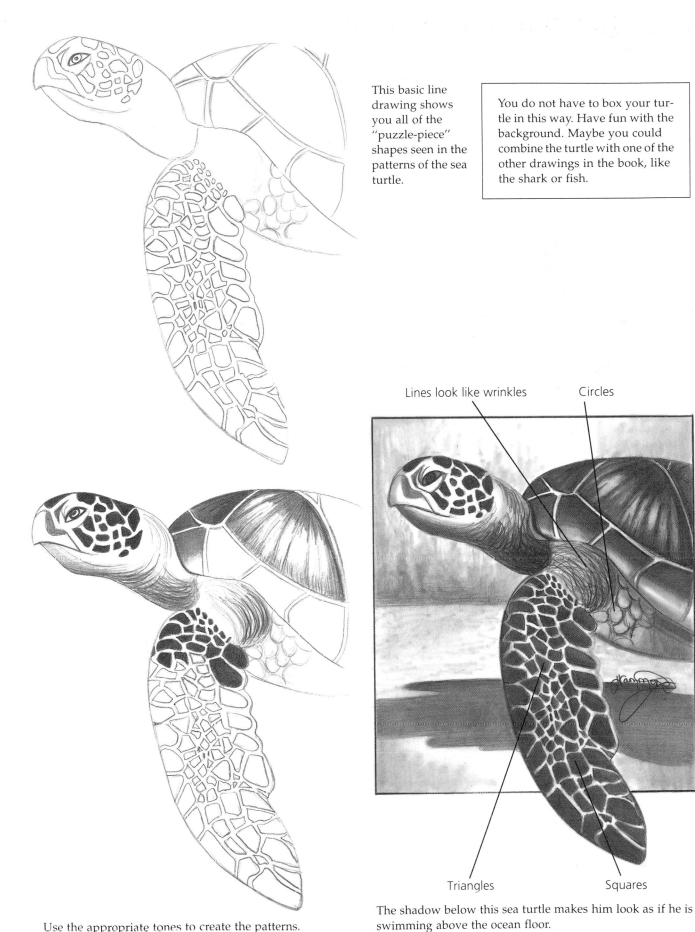

This basic line drawing shows you all of the "puzzle-piece" shapes seen in the patterns of the sea turtle.

You do not have to box your turtle in this way. Have fun with the background. Maybe you could combine the turtle with one of the other drawings in the book, like the shark or fish.

Lines look like wrinkles

Circles

Triangles

Squares

Use the appropriate tones to create the patterns.

The shadow below this sea turtle makes him look as if he is swimming above the ocean floor.

SHOWING MUSCLES

Besides dogs and cats, horses are the most popular animals to draw. Horses have very muscular faces and bodies. The first example uses a picture of my friend's horse, "Reward." Since you are already familiar with the procedure you need to follow to make it look real, try something different with this one. Put a 1½-inch graph on your drawing paper and make this real big (10½ inches high). Think you can do it?

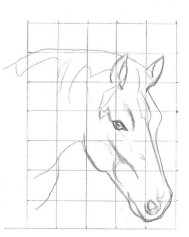

Accurate line drawing.

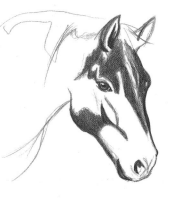

Placement of the dark areas (#1).

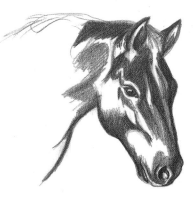

Continue with medium dark areas (#1) and (#2).

#1	#2	#3	#4	#5

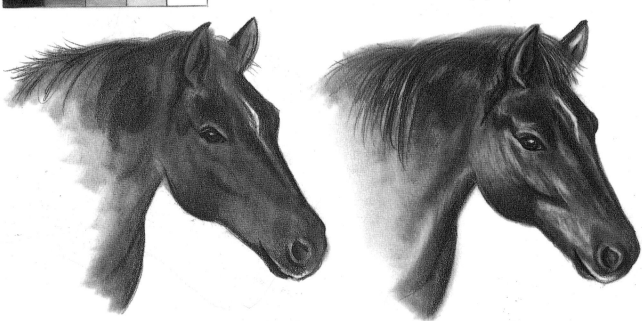

Blend until smooth.

Lift lighter areas and highlights with kneaded eraser. Add more details, such as the hair in the mane. Keep balancing lights and darks until you like the results.

This area resembles the sphere exercise due to the roundness.

Here are two more "horsey" drawings for you to try. Keep these things in mind as you draw.

1. **SHAPES** What is the overall *basic shape*? What kind of shapes are created in the boxes of the graph? See the lights and darks as puzzle-piece shapes.

2. **CONTRASTS** Where is it light? Where is it dark? What are the shapes of these light and dark areas? Do these lights and darks overlap?

3. **BLENDING** Is your blending smooth? Does your blending follow the shapes? Are you blending in the same direction of the pencil lines? Did you "lift" the light areas to help make it look real?

Use a 1-inch graph for this picture of a colt. Include the ground line and shadows to give it solidity. Watch for how the shadows have helped rounded areas look real. The light areas are where the surface is sticking out farther than the rest.

Turn a horse into a unicorn for fun. On this drawing, look for how the white of the mane has been lifted out against the dark of the neck, and the highlights of the face have been lifted too. Try turning another horse into a Pegasus.

PATTERNS

Here is another creature for you to work with that has interesting patterns on its skin. His shape may seem unusual, but go back to the basic shape theory to simplify it. He is clearly egg-shaped!

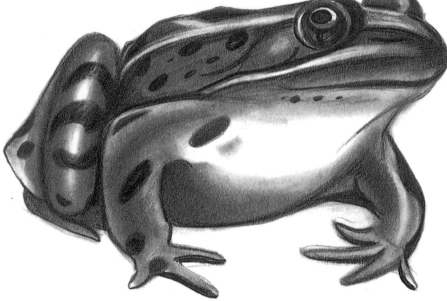

Finished drawing.

Note: What kind of background or scene can you think of for this little guy? Long grass would work, or the edge of a pond. Go through some wildlife books or magazines and find something that is interesting to you.

There is a wide range of different looks that you can give your artwork. When you are drawing, ask yourself, "What do I want my work to say?" Think of why you are doing it. Are you illustrating a report for school or work? Then a boxed, graphic look might be good. Are you drawing someone's pet? Then maybe a portrait look that fades out at the bottom would be better. Is this something that you would like to frame and hang on the wall? Then maybe it would look good with scenery behind it. Are you doing it just for fun? Then make it simple.

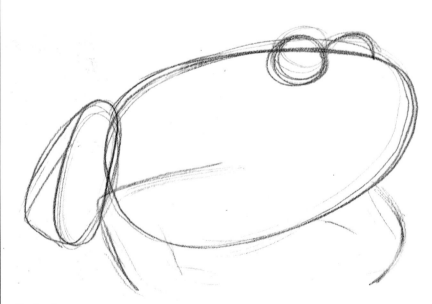

Basic shapes.

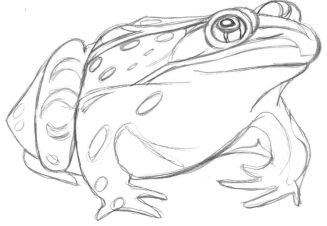

Accurate line drawing. Be sure to capture all of the design shapes.

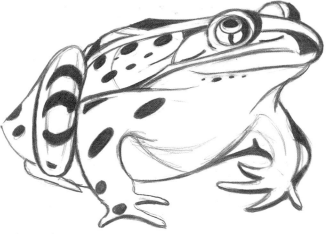

Add the #1 darks to the patterns.

Add the lighter tones, the #2 and #3 darks.

Blend to make him look smooth. If some of the dark areas get too light after blending, darken them once again.

PRACTICE PATTERNS

Zebra

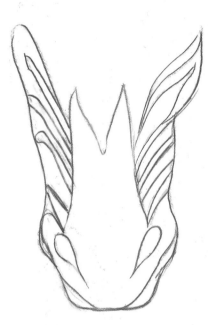

Accurate line drawing.

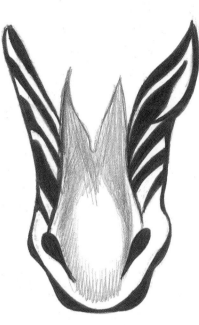

Fill in the stripes solid black with #1 dark.

Blend to create the shadows and shape. If the stripes lighten up, fill them in once again.

Leopard

Other markings are drawn the same way: shape.

Patterns.

Blend; dark patterns again.

Tiger

Drawing animals with patterns is easier than it looks. Do you know why? It is because their markings are nothing more than *shapes*, and anytime you can break something down into shapes, it is easier to draw. (Keep in mind the box exercise in chapter three.)

Look at the zebra. By placing your box graph over it, you have created an exercise much like the box graph of the tiger. The patterns that are created are very similar. Try drawing this zebra upside down in the graph and concentrate on just drawing the little shapes. When you have completed the line drawing, continue on and make it look real.

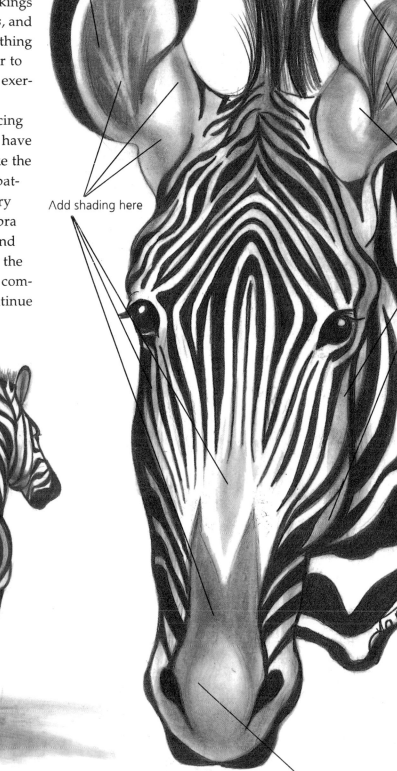

Lift light hairs

Lift light hairs

Add shading here

Add shading here

Gently blend the nose

A zebra is so beautiful because of its markings, even from behind!

CAT PATTERNS

The "cat" family is another good example of animals with beautiful markings. Take a look at this example. The overall shape of the tiger's head gets you started, the designs and patterns take you halfway there, but the shading is the trick to make it look real. Both the tiger and the leopard would look very flat without the addition of some blending to the drawing.

Place your graph over this and have fun. Refer to page 64 to see how to draw the markings and blend the tones.

Note: Be sure to darken the markings if they lighten up during blending.

Follow the same procedure to create this beautiful leopard. Think of ways you could put a background with it. You could just put some light shading be-hind it, or you could put some trees in there. Or left just as it is, this drawing would look good with an oval mat around it and hung on the wall.

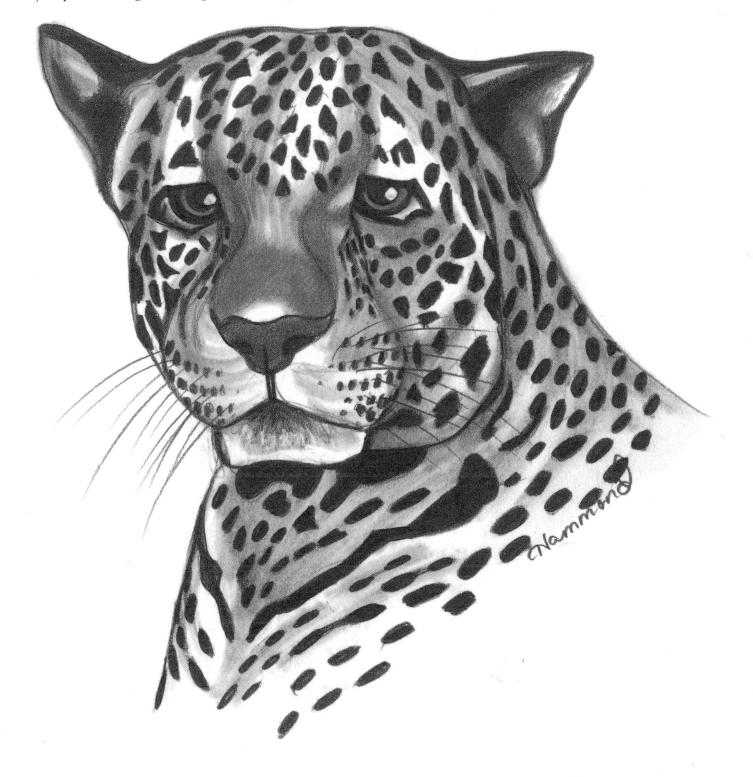

GIRAFFE PATTERNS

How many other animals can you think of that have unusual patterns and markings? My favorite is the giraffe. Not only are the markings very striking, the over-all basic shape of a giraffe is unique. To me, a giraffe looks like it shouldn't even be real!

See what you can do with this guy. Keep in mind that he is *shape* first, patterns second and blending third. His markings are not black like the animals before; they are more of a gray tone, and he has a lot less white in between the markings. Look at the shadows that are being cast on the legs and the shadow on the ground below him. These are the things that will make the giraffe look real, so include them in your work.

Now that you have a lot of practice drawing, it may be time for you to try to put a little more into your drawings. Look outside

the window and see if there is a tree that you could add to your drawing (remember to make the tree the right size).

Taking all of the information that you have learned so far, study the photograph of this giraffe. Can you now see the drawing procedure in your mind as you look at it? Are you able to see the giraffe as shapes? Are you able to see where the darkest darks are? (Remember to squint your eyes!) Are you able to tell which areas are blended and which are in line?

Draw this giraffe. Take either of your graphs and make an accurate line drawing. Feel free to make it any size you want. Study my artwork. Look for the areas where I have blended. Look for areas where I have "lifted" light. Look for areas that are made up of lines (in the mane).

By now, you should have enough practice to draw this giraffe on your own, and the techniques should be coming a bit more natural to you. Take your time and proceed slowly. Don't give up until you are satisfied with the results.

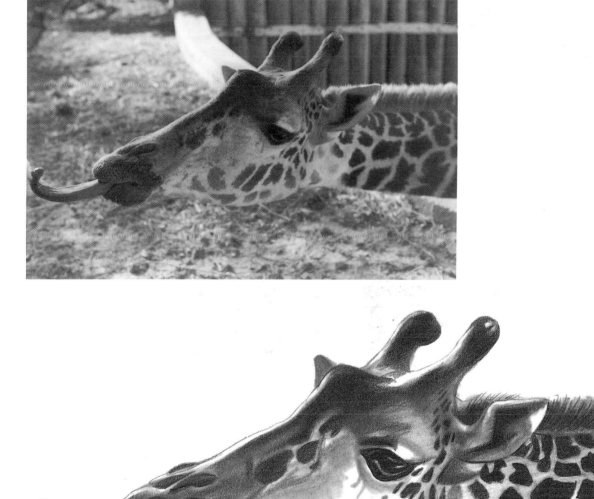

BIRD MARKINGS

Just like animals, birds have markings too. But, with the individual feathers, they are somewhat more complex and challenging to draw. Again, being able to see the small shapes that make up the patterns will help you draw them.

Look at this falcon. Each feather is a separate challenge to deal with, but by taking it one feather at a time, it is easier.

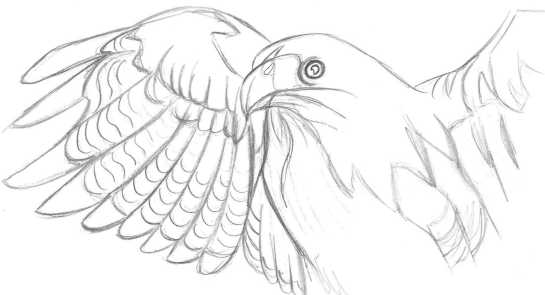

Look at all the many shapes created in the feathers.

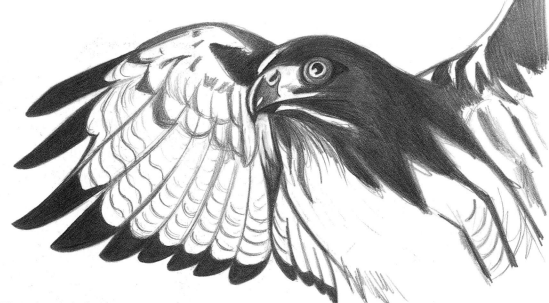

Place the #1 darks.

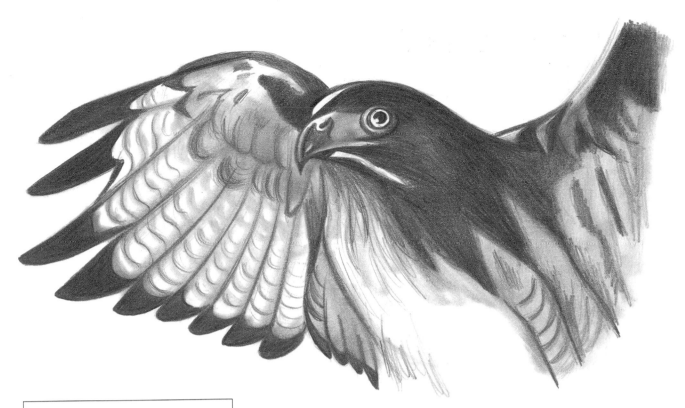

Blend, to make it look real!

Note: Instead of boxing in this bird, use your tortillion to create the look of it flying out of a cloud. Or, find out how the rest of the bird looks, and draw it landing on a branch or catching a fish.

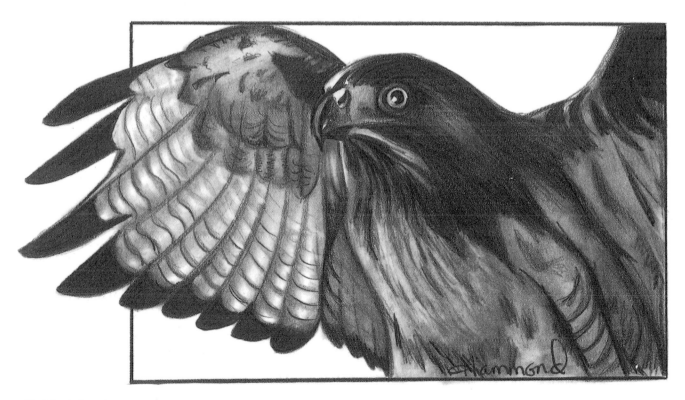

Finished drawing.

COMPOSITION

When creating a "finished" drawing, it is important to take into consideration the way you place your drawing on the page. This is called *composition*. Look at the drawing of the koala holding onto its tree. You can see how the drawing creates a diamond shape. This is called a diamond composition. Below is a diagram showing the many shapes that can be used for placing your subjects on the page.

Another important note about composition: *Always* place your subject closer to the top of the page than the bottom, *not* in the middle. There should always be more empty space at the bottom of the page than at the top.

Draw this koala. *Remember the procedure!*

The darkness of the tree accents the light fur of the koala.

Light hairs are "lifted."

Circular

Oval

Triangular · Diamond

Eyes are drawn with a stencil.

See how the darks and lights work together, especially where the dark areas of the tree help the light side of the koala's face show up? The tree is created by using some dark lines straight up and down, in a rough fashion, blending it out and pulling the highlights out on top.

Rectangular or square

Tree bark is just dark, rough lines with the light lifted out.

This drawing has been faded into a diamond-shaped composition.

These are examples of triangular compositions (actually, the ram looks more like a heart). They are beautiful animals to draw. Each of these would make a nice, frameable piece of art if done a little larger. Refresh your memory on how to enlarge the subjects (see pages 18 and 19). Place them closer to the top than to the bottom of your drawing paper.

Look at the effects of light on the ram horns and the deer antlers—light gives them the illusion of roundness. When drawing them, draw the shapes first and then apply all the darks. Study to see "Where is it light against dark and where is it dark against light?" Pull out the lights with the eraser.

I like the way the drawing fades at the bottom of the deer. It gives it a very artistic look. The ram was given a more solid, sturdy edge at the bottom, which helps give it a "bold" look. Experiment with different approaches when finishing your work.

Texture is "lifted out" with the eraser.

Light areas over dark areas.

Look for more areas of "light over dark."

Don't forget the catchlights in the eyes and highlights on the nose.

The pupil is oblong.

Beautiful texture created by the shape and the effects of light.

Long, light hair "lifted out."

This panda bear makes you feel relaxed just looking at it, doesn't it? It is an example of a circular composition. As you can see, the trees were drawn mostly with the tortillion.

CHAPTER TEN

SETTING

I like to draw unusual things. I saw this picture of a bat and, just for fun, created the background to give it a kind of Halloween look.

Notice how the moon is a sphere with some craters hinted just by blending. The clouds are just dark areas blended in with the tortillion.

The bat itself gives you practice with both smooth surfaces, like the wings, and furry surfaces in the body. Although there aren't any markings to deal with, the divisions in the wings make three different shapes. Study the wings closely. Can you see the light areas that have been lifted?

SETTING THE STAGE

Here are some drawings I did from photos I took at an exhibit. This shows what you can do with your own photography. Take your camera with you to the zoo, the circus, the park or anywhere you go! It is so much fun to create your own photo references and do drawings from special places you have been. Your artwork can be a wonderful way to remember the vacations you've taken and the places you've been.

As you can see, it is not important to include every little detail from your photograph. This is "artistic license." You take what

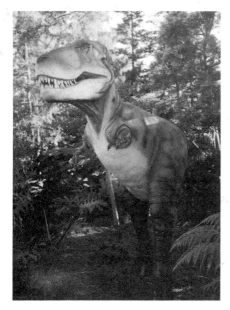

you want from the photo and leave out the stuff that you don't. Can you see how I have simplified the trees in the background? I put enough of them in to make the drawings look interesting, but kept the background simple enough that the trees did not compete with the dinosaurs.

Here are some helpful hints to remember when drawing trees. If the trees are close up, like the one in the koala drawing, then you put in a lot of details with your pencil. If the trees are in the background—as in these dinosaur drawings or the one of the panda—then use your tortillion a lot, to make them look out of focus and farther away.

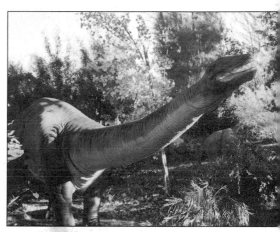

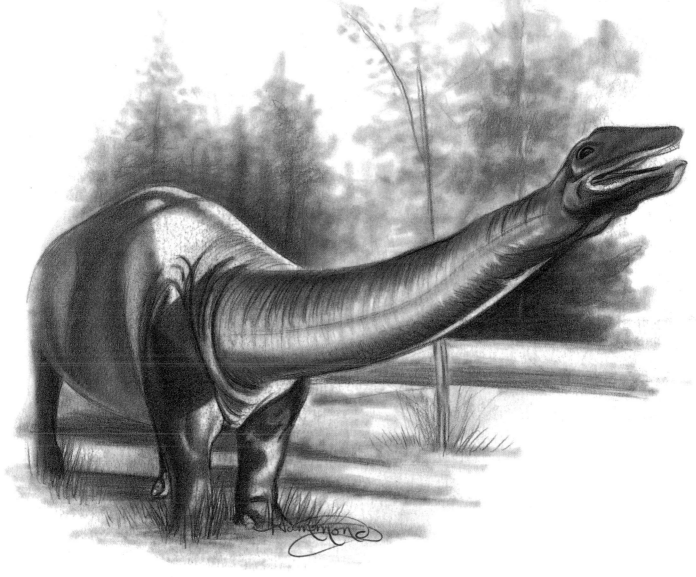

DRAW ME!

This is the dinosaur we used for our "upside-down" drawing in chapter three. Do you still have your line drawing? Finished, it would make a nice piece of art-work. Now is your chance to be truly creative. Think of how you would like to make this drawing look. Do you want to do the whole dinosaur with the trees in the background? Or do you want to make it graphic looking, by en-closing it in a border box? You also could create a dino-portrait, by drawing just the head and fad-ing it out at the bottom. The choice is yours. Whatever presen-tation you decide to do, the draw-ing procedure is the same. Here is a checklist of all of the guidelines that we have covered. These are the secrets to *make it look real*!

1. Look for the *basic shapes* (sphere, cylinder, egg and cone).
2. Look for the puzzle-piece shapes that are created when you place your graph over the photo.
3. Look at the darks and lights as shapes also. Watch for the way they connect.
4. Make sure your outline is accurate before removing your graph.
5. Squint your eyes so that you will be able to see the tones better.
6. Assign each of the shapes a tone from the five-box value scale.
7. Always place the darks first.
8. Blend from dark to light.
9. Keep your blending smooth.
10. "Lift" the light areas and highlights out with the kneaded eraser. Use a point for smooth areas and a ra-zor edge for hairlines.
11. Decide what type of presen-tation you are creating with your artwork and choose your background accord-ingly.

CONCLUSION

Well, there you have it! I hope you have enjoyed the book and taken the time to do the assignments. Drawing is such a rewarding experience and even more so when your artwork truly looks real. As a conclusion, let me once again "show off" some of the beautiful work done by my younger students. I think you'll agree that they did a wonderful job and are an inspiration to everyone. I know that with the right amount of practice and dedication, you, too, can *MAKE IT LOOK REAL*! Have fun, and best of luck!

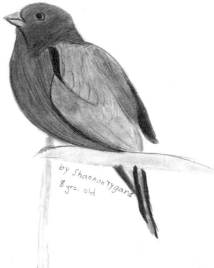

Drawing of a Bird
by Shannon Tygard, age 8

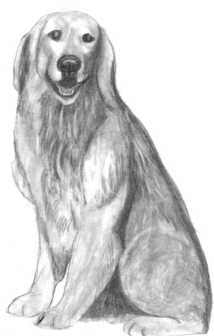

Drawing of a Dog
by Cami Webster, age 10

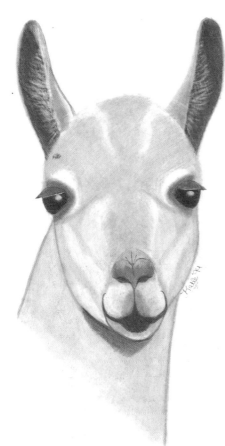

Portrait of a Llama
by Katie McGee, age 10

Killer Whales
by Katie Eager, age 9

Portrait of a Cat
by Katie McGee, age 10

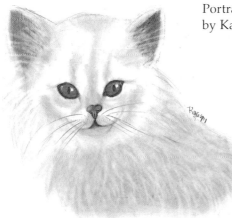

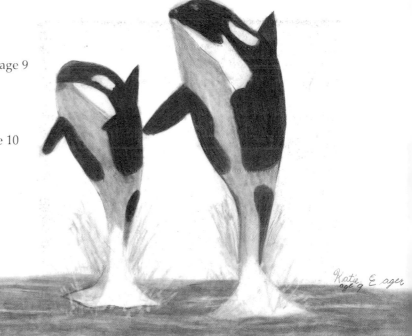

INDEX

B
Backgrounds, 45, 59, 62, 67, 77-78
Bats, 75
Bears, 32, 74
Birds, 31, 70-71, 79
Blending, 9, 17, 22-32, 34-44, 47-49, 54,
 57, 61, 66, 75, 78

C
Cats, 17, 28, 41, 43, 66-67, 79
Color, creating the illusion of, 17
Composition, 72-74
Cones, 26
Contrast, 8, 61
Crosshatching, 58
Cylinders, 26

D
Deer, 73
Dinosaurs, 20-21, 76-78
Dogs, 8-9, 33-35, 42, 46-50, 79

E
Elephants, 53-54
Erasers, 10
 using, to lift tone, 17, 23, 25, 29, 41,
 49, 53, 55, 78
Exercises, drawing shapes, 12-15, 18-19
Eyes, 29, 36-37, 43, 72-73

F
Facial features, 36-39
Fish, 55-56
Flamingos, 30
Fox, 43
Frogs, 62-63
Fur. *See* Hair and fur

G
Giraffes, 68-69
Gorillas, 50
Graphs
 bar, 12-19, 29-30, 41, 48, 52, 60-61,
 65-66, 78
 overlay, 10, 16

H
Hair and fur, 40-51, 75
Halftone, 23
Highlights, 9, 49
Horses, 60-61

K
Koalas, 72

L
Lifting out, 9, 22-23, 30-31, 39, 41, 50, 53,
 56, 61, 75, 78
Light, 23-26, 36-37, 55-56, 73
Lions, 49
Llama, 79

M
Markers, 10, 16
Markings, 70-71
 See also Patterns
Mice, 27

N
Noses, 38-39

O
Otters, 51

P
Paper, 10
Patterns, 65-69
 See also Markings
Pencil lines, 17, 22, 24, 32, 40-44, 48-51
Pencils, 10, 23, 26, 31-32
Photos, drawing, 8, 16-17, 34, 46-47,
 52-53, 60, 69, 76-77
 upside down, 20-21

R
Raccoons, 51
Rams, 73
Realism, creating, 8, 16-17, 22
Reducing and enlarging, 18-19, 52
Reptiles, 58-59
Rhinos, 55
Ruler, 10

S
Seals, 29
Settings, 75-77
Shading, 22-27, 29-32, 38, 57, 66
Shadows, 23-26, 54, 59, 61
Shapes, 8-9, 12-22, 26-33, 39, 46, 50, 55,
 57, 61-65, 70, 75, 78
Silhouettes, 13
Sketches, 9
Snakes, 57
Spheres, 23-26
Squirrels, 44-45
Strokes. *See* Pencil lines

T
Templates, 11
Texture, 31-32, 52-59, 73
Tone, 23, 32-35, 37-38, 47, 53, 59, 68, 78
Tortillions, 10, 22, 24, 26, 29, 31, 40, 71,
 77

V
Value scale, 23, 29, 31

W
Whales, 79

Z
Zebra, 65